IMAGES
of America

REDDING
AND EASTON

IMAGES
of America

REDDING
AND EASTON

Daniel Cruson

ARCADIA

Copyright © 2000 by Daniel Cruson.
ISBN 0-7385-0421-1

First published in 2000.

Published by Arcadia Publishing,
an imprint of Tempus Publishing, Inc.
2 Cumberland Street
Charleston, SC 29401

Printed in Great Britain.

Library of Congress Catalog Card Number: Applied for.

For all general information contact Arcadia Publishing at:
Telephone 843-853-2070
Fax 843-853-0044
E-Mail sales@arcadiapublishing.com

For customer service and orders:
Toll-Free 1-888-313-2665

Visit us on the internet at http://www.arcadiapublishing.com

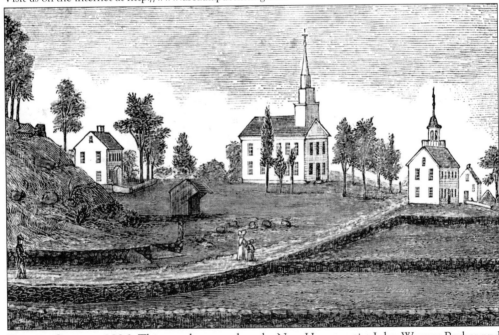

EASTON CENTER, 1836. This woodcut was done by New Haven artist John Warner Barber and is the earliest image that we have of either town. In the center is the newly constructed Congregational church. Across Center Road from the church is the Staples Academy, which was constructed some 40 years before this drawing was done. Behind the church is a house that served as a parsonage for many years. In the mid-20th century, it was the home of Richard Grieser, the proprietor of the general store that still stands across from the church. The carriage shed—once the feature of every New England church in the age of carriage transportation—stands prominently between the house and the church.

CONTENTS

ACKNOWLEDGMENTS

The bulk of images that have gone into this photographic history have come from three primary sources: the archives of the Historical Society of Easton, the archives of the Redding Historical Society, and my own collection of photographs. This core of photographs has been supplemented with images from several generous individuals, who scoured the collections of their neighbors and friends in search of just the right picture to fill in a gap.

Several individuals deserve special recognition for their efforts, without which this project would have been stillborn. Judy Wylie, the past president of the Redding Historical Society, is responsible for initiating the project and deserves full credit for the fact that this work is in front of you. Charlie Couch, the current president of the Redding Historical Society, endured many hours of unrelenting chatter and humored me in my choices, as I happily worked my way through his society's photographic archives. He is to be thanked not only for that but also for contacting some of the people who lent us their precious family photographs. His counterpart in Easton was Lois Bloom, the current president of the Historical Society of Easton. She is to be recognized and thanked for her forbearance with the countless reminiscences of my childhood in Easton that I related while pouring over her society's marvelous photographs. I also thank David Morgan for keeping us company and cutting several badly needed checks to cover expenses. I especially thank Jim Dicuffa for the many hours he spent in the darkroom working to ensure that I had the best prints possible for this work.

I am very grateful to several other individuals who supplied one or two special photographs that added sparkle to this work. Among them are Hugh Carracker, for photographs of Redding Ridge and Redding Center, and Brent Colley, who took time from planning his wedding to make sure that I had some unpublished photographs of Georgetown. I also want to thank my Local History students, whose research helped supply material for captions. I would especially like to thank Lindsey McCarty for her work on Silverman's Farm.

I also give special thanks to my wife, Carolyn, and three very patient sons, Daniel, Thomas, and Benjamin, who fairly cheerfully endured several Nintendo-less nights, as I struggled over musty images in the family room. It is over, guys. Mario Kart awaits.

INTRODUCTION

Redding and Easton, besides sharing a common boundary and a high school, appear to be very different towns with their own history and identity. Treating them together in one photographic history would seem to defy common sense. However, the two towns have much more in common than is apparent at first glance. It is the purpose of this volume to illustrate that similarity.

Both towns were scions of Fairfield. The land that later became Redding, Easton, and Weston was purchased from the local Native Americans as part of the Northern Purchase in 1671. Settlement of this area began for Redding sooner than for Easton because there were a number of Colonial grants of land that were made in the area known as the Oblong. This strange piece of real estate, which measured 2 miles wide and 7 miles long, was land that had gone unclaimed by any of the surrounding towns of Fairfield, Ridgefield, Danbury, or Newtown. This land served as a magnet to attract early land barons, such as John Read and Samuel Couch. The area also attracted enough settlers to create the parish of Reading in 1729 and a separate town in 1767.

Easton's development was a little slower. Early settlement did not begin until the 1730s and 1740s, when the third generation of Fairfield proprietors, finding that farmland was becoming scarce in coastal areas, moved inland to the northern land holdings of their parents. There was a sufficient population to support a parish here as late as 1763, when the parish of North Fairfield was established. Even after the Revolutionary War, Easton did not have a population large enough to support town status, and so it joined the parish of Norfield to become Weston in 1787. Finally, by 1845, the North Fairfield parish was large enough to become an independent town and Easton was created.

For all the apparent differences in the creation of Redding and Easton, the nature of both developing towns was quite similar. Both towns remained agricultural communities despite competition from the Midwest, which was growing with the expansion of the railroad. In the mid-20th century, both made the shift from an agrarian to a suburban community. Chapter One attempts to illustrate the rural nature of the area, using images made in the early 20th century.

Rather than developing around a centralized village (as Newtown, Ridgefield, and Bethel had done), Easton and Redding developed as a collection of self-sustaining communities that centered on their own schoolhouse, store, or tavern. Many also had a local blacksmith shop, and a few even developed their own post offices. Thus the communities of Plattsville, West

Redding, Redding Ridge, Adams Corner, Redding Center, and Georgetown were formed. Their distinctive look is the subject of the second chapter.

Both Easton and Redding toyed with the Industrial Revolution. They each had small support industries in the form of a sawmill, a gristmill, and a fulling mill (a mill for finishing wool cloth). They even had a scattering of craft shops that produced shoes, hats, shirts, wire cloth, buttons, and combs. There were even two ironworks, one in the Foundry District and the other in Sanfordtown. All of these nascent industries failed to develop except Gilbert and Bennett, which had the benefit of the railroad to cut transportation costs and to reduce the time it took to get its product to market. Chapters Three and Four show several of these early industrial attempts and the one successful attempt, which created Georgetown.

The similar cultures of Redding and Easton were maintained by their comparable educational and religious institutions. Chapters Five and Six reveal how similar these institutions were, even to the point of the architecture of their buildings. Both towns were refined communities that valued advanced education. Chapter Five shows not only the little one-room schoolhouse but also the numerous academies that developed here, especially in Redding. Some of these, such as the Staples Academy, the Redding Institute, and the Sanford School, drew students from all over the Northeast, not just from Redding and Easton. In light of the attitude toward advanced literacy and the salubrious climate and rural atmosphere, it is little wonder that the two towns became a haven for many literary figures and artists, as well as for several wealthy residents of New York who were looking for a weekend and summer retreat from the urban clamor. Chapter Seven includes many of these notable people—from Mark Twain and Ida Tarbell to Commodore Luttgen, the Huntingtons, and Bellamy Partridge—in addition to several personalities who, the reader may be surprised to learn, called Redding or Easton their home. The literary and artistic tradition continues to the present day. It is not the purpose of this volume to document the postwar era photographically; therefore, the towns' contemporary literary and artistic personalities do not appear. However, the people who created the atmosphere so congenial to these contemporary figures are readily apparent in Chapter Seven.

Finally, both towns developed similar personalities as they experienced events and personalities of the same nature that marked their history and guided and shaped their growth. The concluding chapter focuses on these events and people. In this chapter, as well as the preceding ones, it is difficult to distinguish the images of Redding from those of Easton. The information in the captions for one town often applies to the other town as well. This closeness, created by parallel rural, agricultural, and industrial pasts, lends cohesion and logic to this volume. This same logic makes it fitting that the adolescents of both towns are educated in the same high school.

Now, turn the page to enjoy Redding and Easton as you have never been able to enjoy them before.

One

REDDING AND EASTON
AS RURAL FARMING
COMMUNITIES

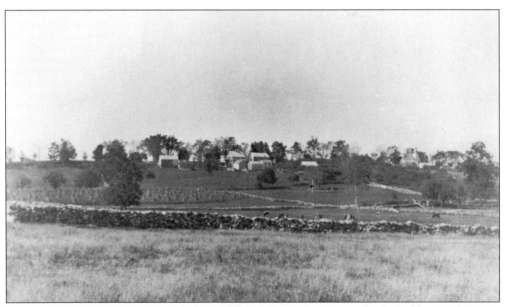

REDDING RIDGE, C. 1910. Until the middle of the 20th century, both Redding and Easton were rural farming communities with much open space, few people, and few buildings. This view of Redding Ridge shows one of the important population centers of Redding in the early 1900s. On the right the spire of Christ's Episcopal Church rises. The stone wall in the foreground conceals Iris Lane.

BLACK ROCK TURNPIKE, LOOKING NORTH, C. 1910. A feature of all rural towns until the middle of the 20th century was dirt or gravel roads. This image shows Black Rock Turnpike (Route 58) on Redding Ridge, just north of Cross Highway. Sunset Hill, or Couch's Hill as it was once known, is visible in the distance.

PANORAMA, C. 1910. This photograph is part of a panorama (a sequence of six photographs) of Redding Ridge taken from the roof of the old Sanford Academy, just north of Cross Highway. This northernmost view shows Sunset Hill in the background and the expanse of cleared fields that characterized most of Redding and Easton during the 19th and early 20th centuries.

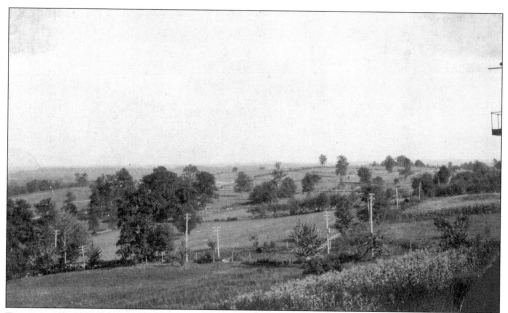

REDDING RIDGE, LOOKING SOUTH, 1910. This photograph shows the the southernmost view of the panorama series. The telephone poles line Church Hill Road. Notice how few trees there are here and in the previous view. Today, there is more forest in the two towns than there has been since before the Revolutionary War.

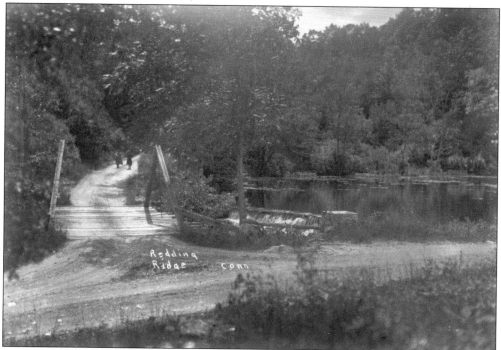

POVERTY HOLLOW, C. 1920. Rural back roads frequently crossed rivers and streams, using small, wooden king-post truss bridges to do so. This image shows the eastern end of Meeker Hill Road, with the old millpond on the right. A sawmill stood on the other side of the bridge, just to the left of the road. The remains of its foundation can still be seen there.

THE MILLPOND AND CAUSEWAY, 1925. Just north of the junction of Meeker Hill and Poverty Hollow Road is a narrow causeway that was built as part of the Fairfield County Turnpike in 1834. This section of the causeway, with the millpond on the right and the log railings, continued to grace the east side of the road until recently. This image of Poverty Hollow is on a postcard that was mailed in 1926.

UMPAWAUG HILL, C. 1910. This photograph looks northeast from the corner of Umpawaug and Topstone Roads. In the foreground is the lot that was occupied by the headquarters of Gen. Israel Putnam during the winter of 1778 to 1779. The saltbox house, just to the right of center, served as the guardhouse that winter. It once held the two prisoners who were executed on Gallows Hill, which appears in the distance. (See page 34.) The house was torn down in 1915.

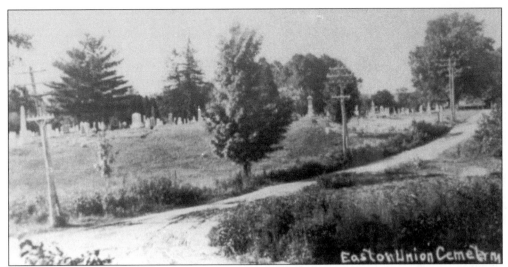

THE ROTARY, C. 1915. A good example of a rural Easton scene is this view of the Union Cemetery, with Stepney Road going off to the right and Sport Hill Road to the left. There actually was a rotary here in the mid-20th century, but an unusually bad and fatal automobile accident in the early 1950s showed how dangerous this intersection was in a time of high-speed transportation and the intersection was rebuilt.

MOREHOUSE HIGHWAY, C. 1925. Morehouse Highway, a typical dirt road, runs south just below its intersection with Center Road. In 1930, the Samuel Staples Elementary School was built on the hill to the left. In 1954, Notre Dame was built straight ahead at the top of the rise. In 1938, the town hall was built just behind where this photograph was taken.

A RURAL EASTON SCENE, C. 1915. Unfortunately, it could not be determined where in Easton this photograph was taken. However, the view is instructive because it shows the small turnoff, sometimes called a "horse tavern," where a rider could water a horse without dismounting.

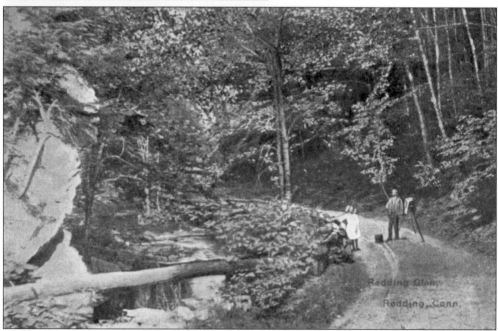

REDDING GLEN, C. 1910. Redding Glen ran from southern Redding into Weston and was considered one of the beauty spots of the county. It was a popular subject for photographers, such as the one shown here. Even Wallace Nutting considered this area so attractive that he featured it in his book *Connecticut Beautiful*.

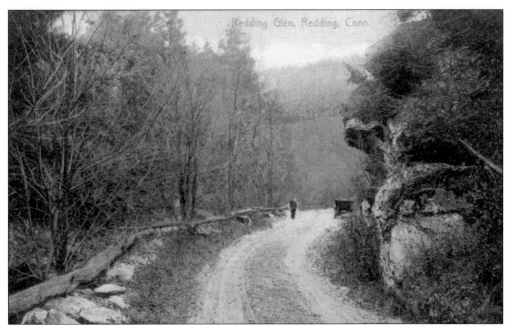

PICTURESQUE ROAD, 1910. This postcard of Redding Glen, mailed in 1912, shows the picturesque road wending its way through the valley, complete with a parked car and its driver, who is enjoying the rural vista. The log guardrails along the river side of the road were typical of most of Easton's and Redding's roads at the beginning of the automobile era.

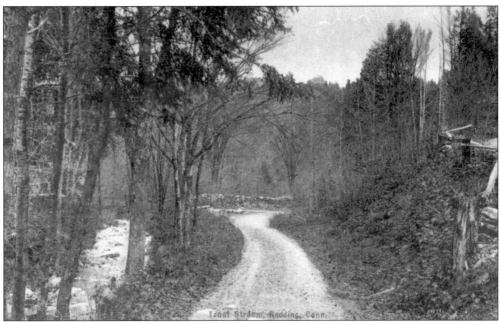

THE SAUGATUCK RIVER, REDDING GLEN, C. 1910. The glen followed the Saugatuck River for most of its length through southern Redding. The rugged and hilly terrain created the beauty of this valley, but it also necessitated the hairpin turns and log guardrails, which are visible on the right.

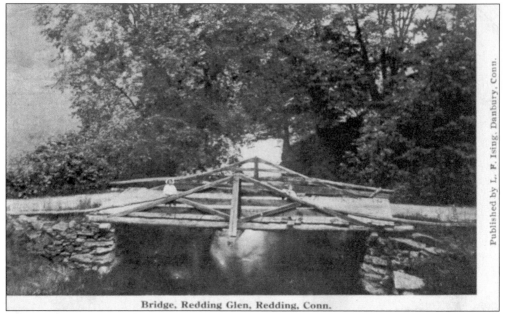

Published by L. F. Ising, Danbury, Conn.

Bridge, Redding Glen, Redding, Conn.

A RUSTIC BRIDGE BRIDGE, C. 1910. In the few areas where the road crossed the river, rustic king-post truss bridges with rails made of logs were used. This bridge was located at the point where the road passed into Weston. The bridge, as well as most of the other stunning qualities of Redding Glen, was submerged under the rising waters of the Saugatuck Reservoir in 1942.

A REDDING FARM, C. 1915. Until well into the 20th century, farming was the main subsistence activity. This typical farmhouse and outbuildings were located on Topstone Road near its intersection with Umpawaug Road.

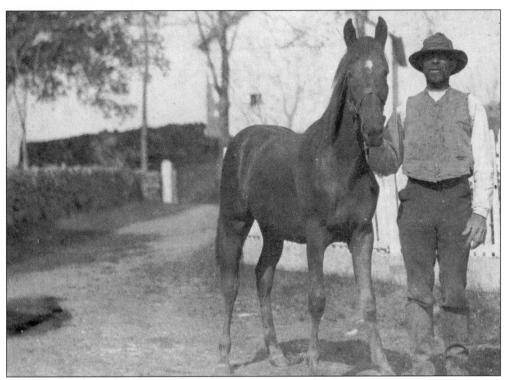

A HIRED HAND, C. 1900. Frank Baldwin is one of several African Americans who worked as hired hands on local farms into the early years of the 20th century. Baldwin worked for Julia Sanford, whose house still stands at 140 Black Rock Turnpike, and he may have lived in the small worker's house that stands across the road and slightly to the south. Baldwin's descendants still live in Redding.

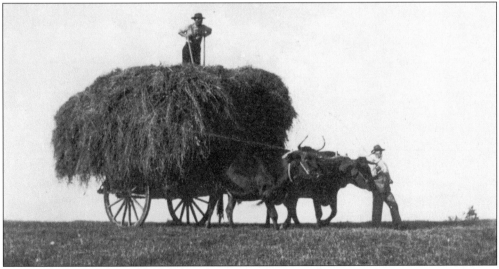

GATHERING HAY, C. 1910. Hired hand Frank Baldwin, standing on the hay wagon, works at one of the many farming chores typical of this area. The image is a scarce cyanotype, a blue photograph made by the same process that produces blueprints. Cyanotypes were popular between 1900 and 1910 and then died out almost completely.

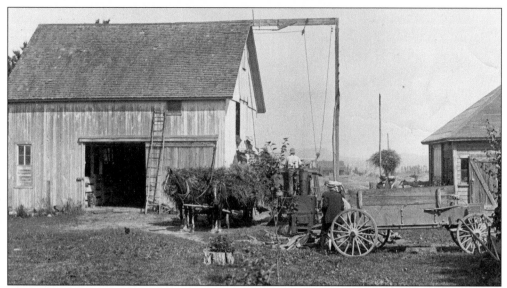

THRESHING AT THE RYDER FARM, 1917. This typical farm scene shows Frank Ryder, the owner of the farm, bending over the exit chute. He is partially obscured by Emory Sanford, who stands by the back wheel of the wagon, with his back to the camera. William Ryder feeds the grain into the machine, and C.A. Hill stands on the load of grain. This farm was located on Umpawaug Hill in Redding.

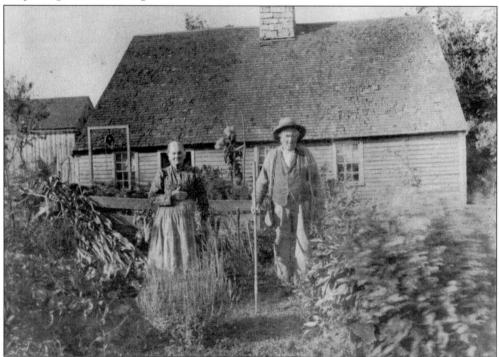

A KITCHEN GARDEN, C. 1900. Tending their kitchen garden, which produced vegetables and herbs for home use, are Ruth and Charles Beach. This house is located on Rock House Road, a short distance east of its intersection with Sport Hill Road. It is reputed to be the oldest house in either Easton or Redding. Charles Frasch, who restored the house, has dated it back to 1683.

18

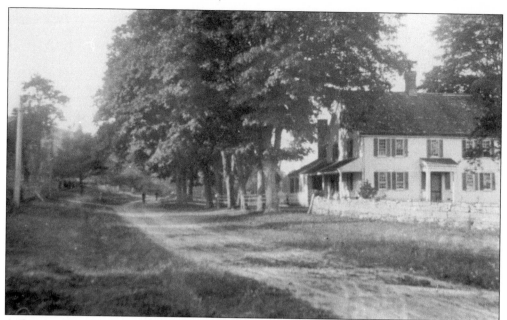

A RURAL HIGHWAY, C. 1910. At the time of the Revolutionary War, this Easton house was known as the Samuel Wakeman House and it stood, as it still does, on Black Rock Turnpike. The British marched up this road on April 26, 1777, on their way to raid Danbury. A pair of gloves was reported stolen after the British passed. When this photograph was taken, the house was owned by the Osborn family.

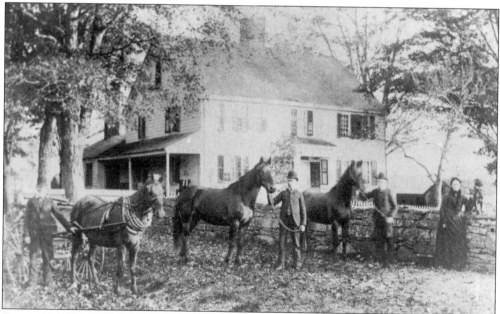

STRIKING A RURAL POSE, C. 1885. The Osborn family poses on Black Rock Turnpike with the animals that were essential in a farm community to supply power for plowing and other farm chores, as well as for transportation. Family members are, from left to right, David Osborn, Orlando Osborn, his son Dr. G.W. Osborn, another son, and Melissa Banks Osborn, wife of David Osborn.

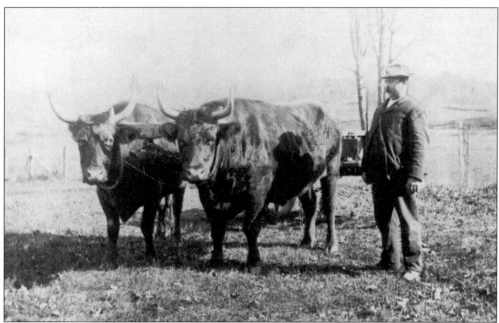

Bucolic Pride, c. 1910. The other major power source for farmers was the ox team. This photograph shows a proud Orlando Osborn with his prizewinning ox team. Oxen were dependable and less spirited than horses but, contrary to popular belief, they could not pull as much as a properly harnessed horse.

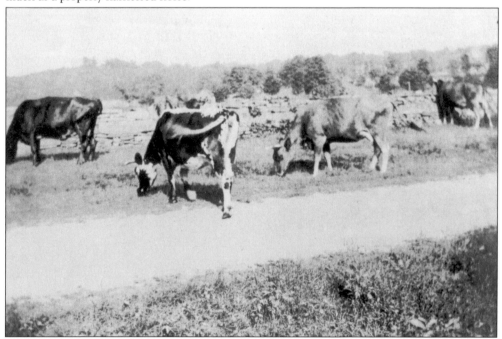

Black Rock Turnpike of a Former Era, c. 1910. Cattle graze by the side of Black Rock Turnpike, just north of Center Road. The animals belong to the Osborn family, whose house is just to the left. To keep cattle from wandering off, farmers frequently put up gates across the road, creating a road hazard that infuriated early auto enthusiasts and the local constabulary.

20

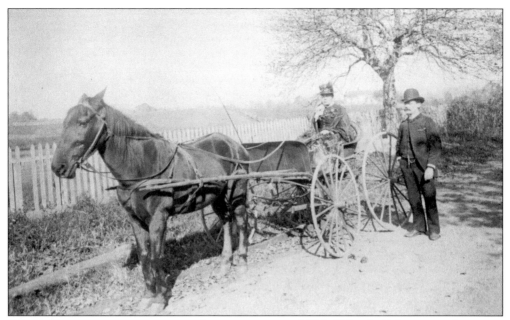

RURAL TRANSPORTATION, BEFORE AUTOMOBILES, C. 1915. Orlando Osborne stands next to his wife, who is ready to pull out onto Black Rock Turnpike in the most common form of transportation in the 19th century. Contrary to many views of the American Colonial era, carriages were rarely used in the 18th century; back then, the usual means of transportation was by horseback.

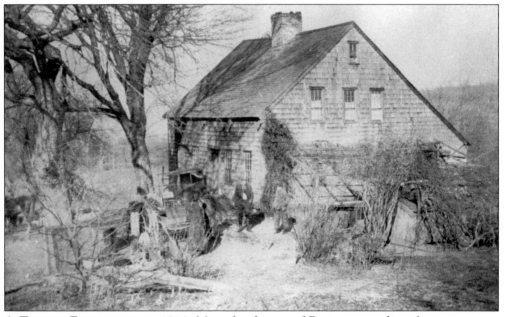

A TYPICAL FARMHOUSE, C. 1910. Many farmhouses of Easton were relics of a previous era, since most farmers here were poor and could not afford to modernize their homes. This mid-18th-century, one-and-a-half-story house was once located on Park Avenue, just south of Flat Rock Road. It was moved to the northern part of town when the Easton Reservoir was built in 1927.

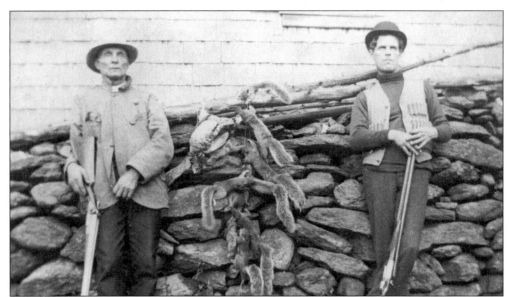

SUPPLEMENTAL HUNTING, C. 1910. This photograph was taken at the old one-and-a-half-story house shown in the preceding photograph. These two men, who have just bagged dinner, are unidentified but were probably related to Tony and Nell Shattrand, who lived in the house at the time. Supplemental hunting frequently added meat to the tables of poor farmers.

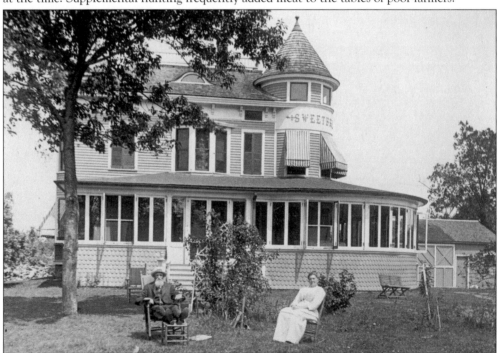

SWEETBRIAR, C. 1900. Not all Easton residents were poor farmers. Sylvanus Mallett and his wife, Mary Marsh Mallett, take their leisure in front of Sweetbriar, their late-Victorian house. The house, which Mallett built, still stands on Sport Hill Road, just south of Sunny Ridge Road. It has been owned by a succession of horse breeders, trainers, and equestrian teachers. (See page 123.)

Two

REDDING AND EASTON
AS A COLLECTION OF
COMMUNITIES

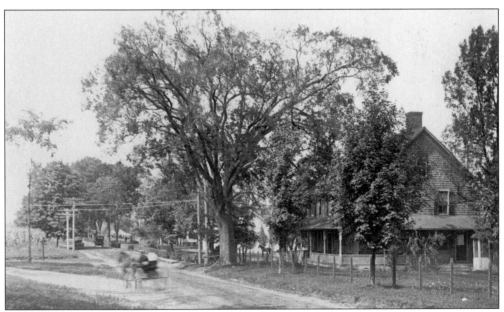

REDDING RIDGE, C. 1915. Redding and Easton were not towns with a well-defined central village, like Newtown and Fairfield. Rather, they consisted of a series of separate communities, usually centered around a schoolhouse, their own stores, and often a church. This photograph shows one of the oldest of Redding communities, which centered on the intersection of Black Rock Turnpike and Cross Highway.

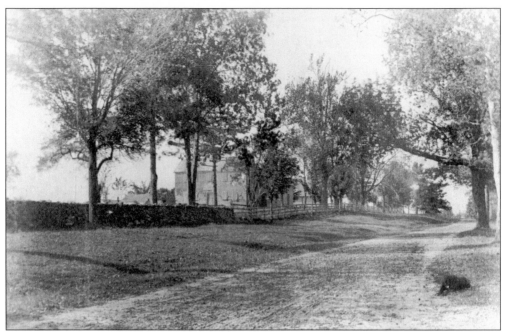

THE SQUIRE WILLIAM HERON HOUSE, 1894. This large saltbox house stands just south of the intersection and Christ's Episcopal Church. Built in the early 1730s by John Beach, the founding priest of the Episcopal church in Redding, the house was owned by William Heron at the time of the Revolutionary War.

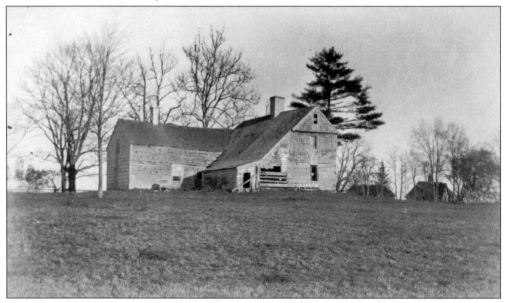

THE SQUIRE'S HOUSE, IN ITS LAST DAYS, 1900. William Heron was a mysterious figure during the American Revolution. Long thought to have been a double agent for both sides, modern scholarship has found that he supplied valuable information about the British to American intelligence officers. He later became one of Redding's most influential citizens. The house was torn down at the beginning of the 20th century, shortly after this photograph was taken.

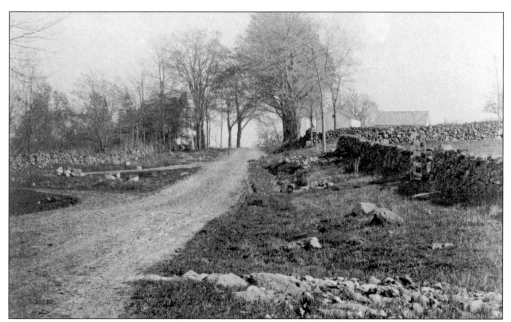

BLACK ROCK TURNPIKE, C. 1910. This section of Black Rock Turnpike ran south along the ridge. On the left is the entrance to Meeker Hill Road. Farther along on the left is Julia Sanford's house, with her barns on the other side of the road, to the right. A short distance beyond was the Redding Ridge General Store.

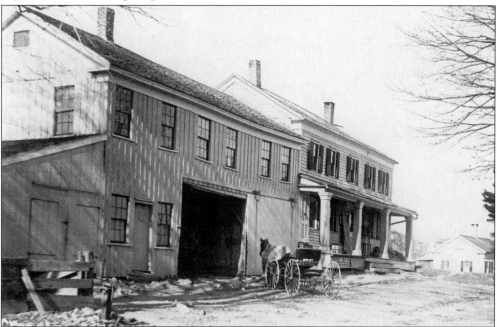

REDDING RIDGE MARKET AND BLACKSMITH SHOP, C. 1900. The building with the front porch long served as a general store to the ridge. It was built c. 1834 by the Fanton family, who ran a shirt factory out of the upper story for years. The blacksmith shop on the left was run by Joseph Busser between 1882 and 1919. This complex was torn down by the Caraluzzi family in 1951 to make way for the modern Redding Ridge Market.

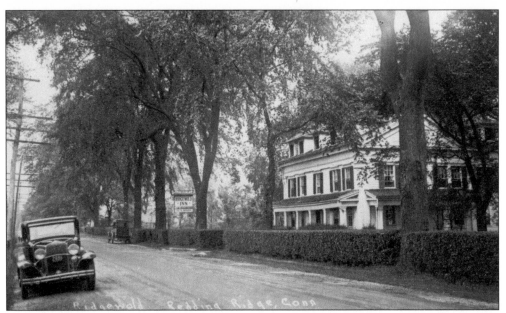

THE RIDGEWOLD INN, 1931. This building was remodeled and enlarged in 1905 to serve as the Sanford School. During the summer months, when the school was not in session, the building was used as an inn, accommodating diners in its restaurant and overnight guests who wished to stay several days and sample the bucolic delights of rural Redding.

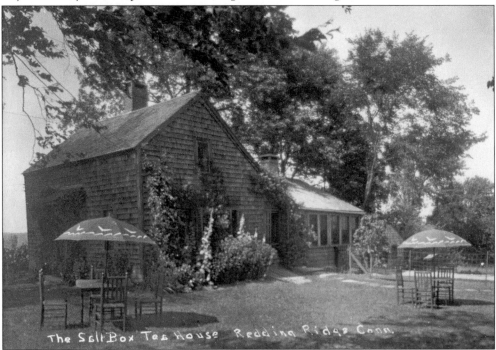

THE SALTBOX TEA HOUSE, C. 1925. This saltbox-style house still stands just north of the Ridgewold Inn. In the 1920s, to cater to the rapidly growing numbers of people who had automobiles and used them to make day trips into the country, teahouses such as this one developed and served a light lunch or offered some refreshment to such day travelers.

THE SPINNING WHEEL INN, C. 1940. Begun by Tottle family in 1925, this late-18th-century house was refurbished to function primarily as a restaurant serving lunch and dinner. It was extensively rebuilt after a disastrous fine in 1948 and went on to become a favorite luncheon spot for elderly ladies out for a day's ride into the country. It has recently been turned into a dinner theater.

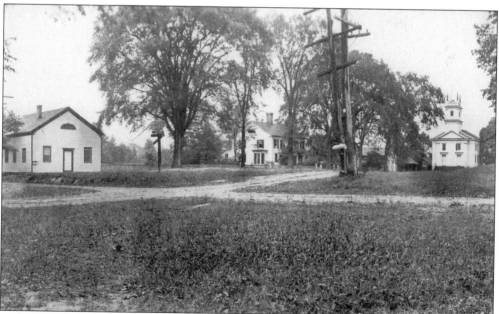

REDDING GREEN, C. 1915. This vista of the Redding Green has changed little since the mid-19th century. It is the heart of the Redding Center community and is dominated by three buildings, from left to right, the Old Town House, the Deacon Abbott House, and the Congregational church, formerly the Methodist church. Today, this is the central portion of the Redding Center Historical District.

THE OLD TOWN HOUSE, C. 1920. Built in the summer of 1834, this building housed the town offices until 1960, when most of the town's officials moved into the remodeled Hill Academy on Lonetown Road. Today, the old building continues to be used for meetings of the Planning and Conservation Commissions and it holds Redding's land use offices.

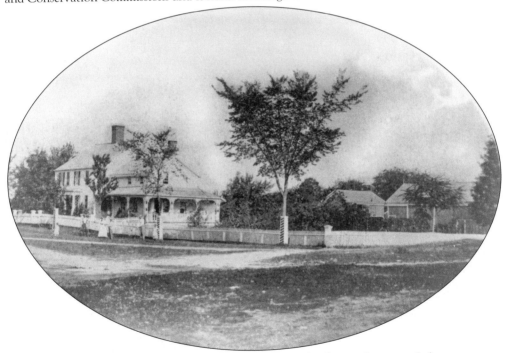

THE GREEN, 1867. Just west of the Redding Green is this house that served the center as a general store and post office during the middle of the 19th century. The photograph shows the store at the time D.S. Johnson was the proprietor.

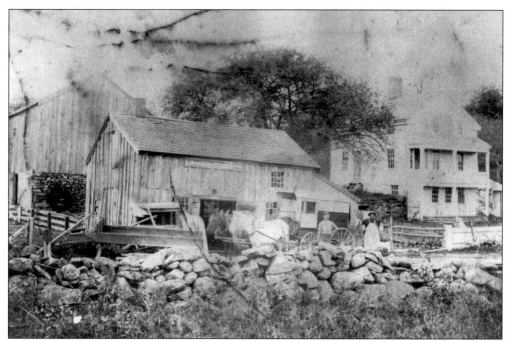

THE FLOOD BLACKSMITH SHOP, C. 1900. To the south of Redding Green, at the junction of Sherman Turnpike and Sanfordtown Road, was the blacksmith shop that served the center community. When this photograph was taken, the blacksmith shop was being run by Michael Flood.

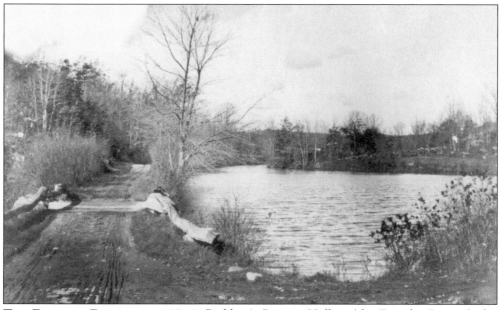

THE FOUNDRY DISTRICT, C. 1910. Redding's Poverty Hollow (the Foundry District) also constituted a community, this one centered around the Sanford Foundry and three small button and comb shops. The causeway and bridge were built for the Fairfield County Turnpike in 1834. The millpond to the right held water that powered one of the button shops, in addition to a sawmill and a gristmill.

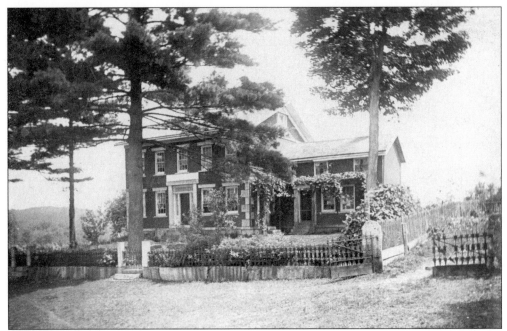

THE SQUIRE SANFORD HOUSE, C. 1905. Squire James Sanford built the Sanford Foundry in 1824 to produce agricultural implements. In 1848, he built this house, located on the east side of Sport Hill Road, as it climbs out of the valley. The foundation stones were quarried on his property, and the bricks were made there as well. The iron fence surrounding the house was cast in the Sanford Foundry.

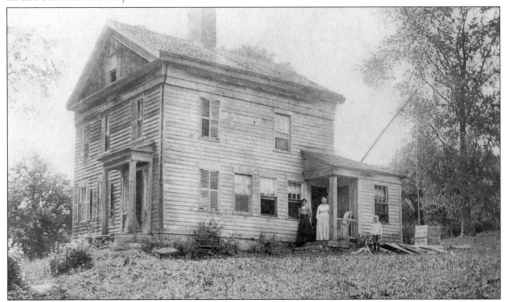

THE LEWIS GOODSELL HOUSE, C. 1905. In the eastern portion of Poverty Hollow (62 Stepney Road) stands this house, built by Lewis Goodsell and his wife, Edna Lacey, in 1840. By the time this photograph was taken, the house had fallen into disrepair. In December 1935, Virginia Kirkus bought the house and extensively renovated it. She later wrote a book about the renovation process called *A House for the Weekend*.

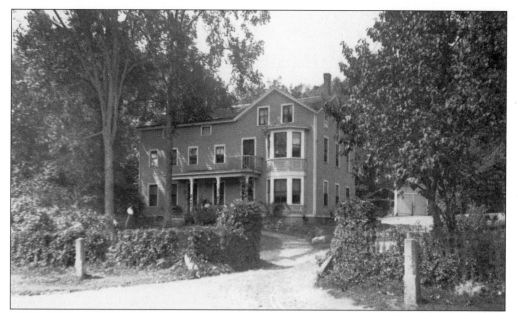

THE STEPHEN SANFORD HOUSE, C. 1910. This house stood on the west side of Poverty Hollow Road, just north of its junction with Valley and Stepney Roads. It was built by Squire James Sanford's son Stephen Sanford, who ran a successful button- and comb-manufacturing business in the Foundry District from 1862 to shortly after the beginning of the 20th century.

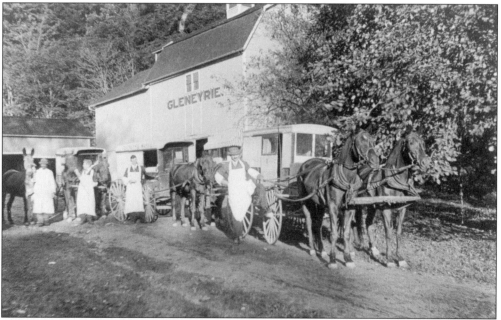

GLENEYRIE, C. 1910. Emory Sanford, son of Stephen Sanford, inherited the house shown in the previous photograph and began a butchering and meat-marketing operation out of the barns. The wagons, shown here, toured southern Redding regularly, selling fresh meat to the housewives along his route. The property was condemned and purchased by the Bridgeport Hydraulic Company in 1914 to keep the waste from the butchering operation from contaminating the newly built Aspetuck Reservoir in Easton.

31

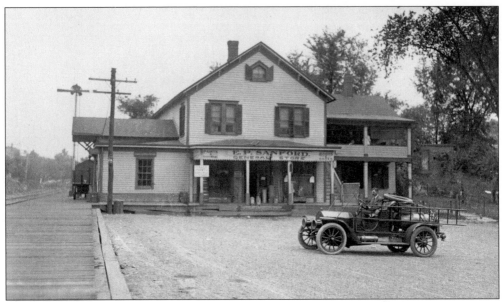

THE SANFORD STORE, C. 1920. After being forced out of his Poverty Hollow home and business, Emory Sanford moved to West Redding and took over this store, which is the heart of the West Redding community. He is shown in front of the store with West Redding's first fire truck. On the left is the freight office and railroad station for the Norwalk Danbury Railroad.

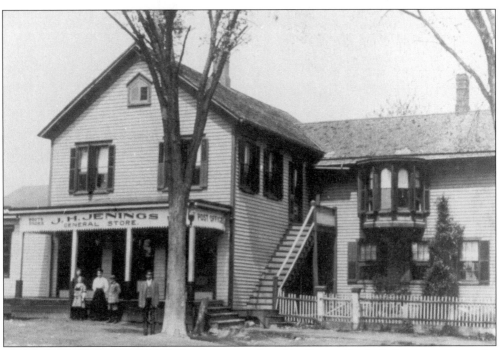

THE JENINGS STORE, C. 1900. Before being purchased by Emory Sanford, this store was run by John H. Jenings. The building, which had been constructed in 1864, was run as a general store until after World War II. During Jenings's proprietorship, the store contained the West Redding post office.

THE WEST REDDING FIREHOUSE, C. 1920. This garage on Simpaug Turnpike just west of West Redding Center served as the West Redding's first firehouse. Out front, Emory Sanford shows off the community's first fire truck.

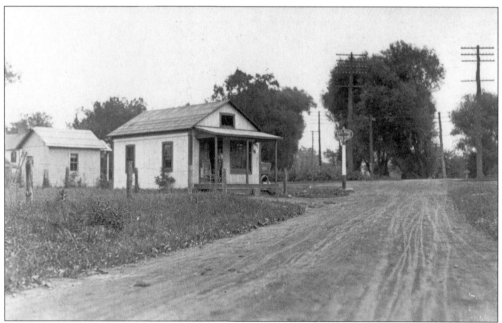

THE GRADE CROSSING, WEST REDDING, C. 1915. This recently identified photograph, taken looking south along Long Ridge Road, shows the West Redding railroad crossing, The building in the center housed a small store. It is not known how long the store was in business, who the proprietor was, nor what was sold there.

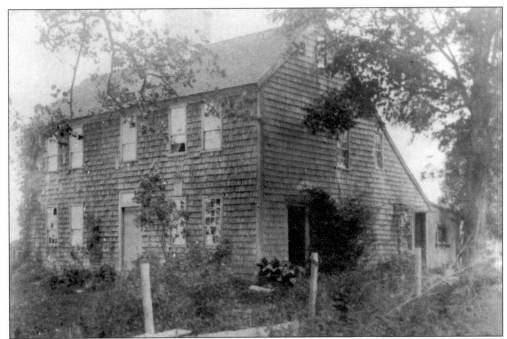

THE REVOLUTIONARY WAR GUARDHOUSE, C. 1915. Although peripherally part of West Redding, Umpawaug Hill was the location of the old Ephraim Barlow House. In this house, Edward Jones and John Smith awaited their execution for spying and desertion, respectively. On February 16, 1779, they were led over to Gallows Hill, where Jones was hanged and Smith was shot. This photograph shows the house just before it was torn down in 1915.

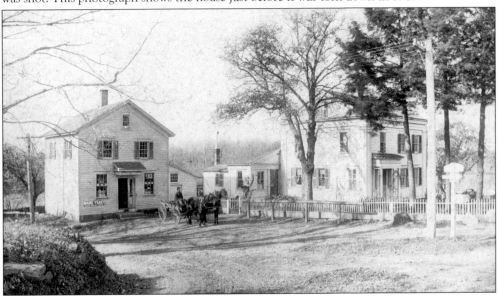

ADAMS CORNER, C. 1900. Located at the intersection of Adams and Sport Hill Road, Adams Corner was one of Easton's liveliest communities. In the early years of the 20th century, the community was centered around Haeublein's store, shown here on the left. Haeublein lived in the house on the right. The community also had a tavern, a blacksmith shop, and a district schoolhouse, all crowded around this intersection.

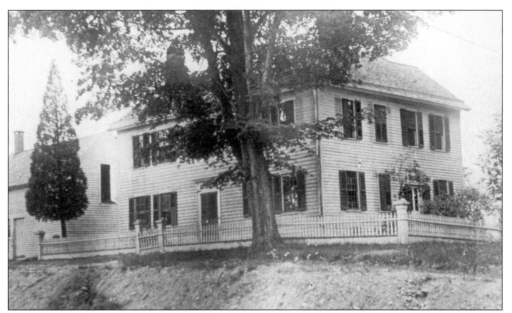

THE ELI ADAMS TAVERN, C. 1900. From the time of its construction just after the American Revolution to 1897, this building served as a tavern and as the center of the Adams Corner community. It had a ballroom on the second floor, which was used for Masons' meetings and social occasions. When Eli Adams owned the tavern in the early 19th century, it was a gathering place for veterans of the War of 1812.

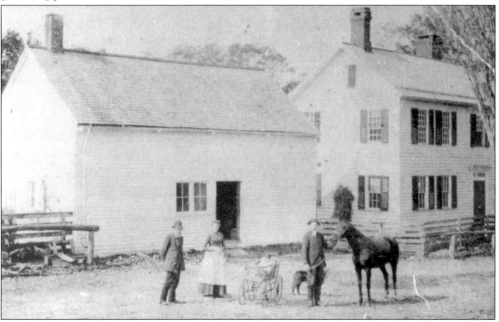

THE ADAMS CORNER BLACKSMITH, C. 1900. This blacksmith shop was located just south of the Eli Adams Tavern. In the early years of the 19th century, and long before Haeublein kept his store across the street, Eli Adams ran a grocery store here. This complex also served as a stage stop on the North Fairfield-Bridgeport Line. After World War II, this blacksmith building was moved to the west of the tavern, where it still stands.

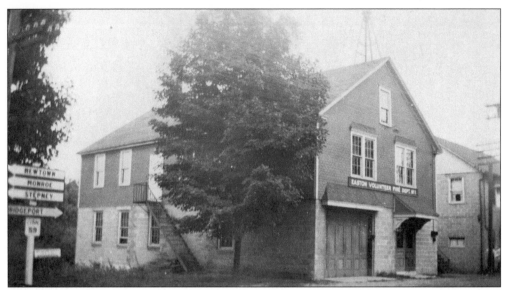

THE EASTON GREEN, C. 1930. The triangular green was formed accidentally as wagons and carriages took the shortest route to turn onto Sport Hill Road from Center Road. This area was not really a community until the construction of the Easton Firehouse in 1927. Then, along with the creation of Halzack's store next door and the use of the green for the annual firemen's carnival, this area became a public gathering place.

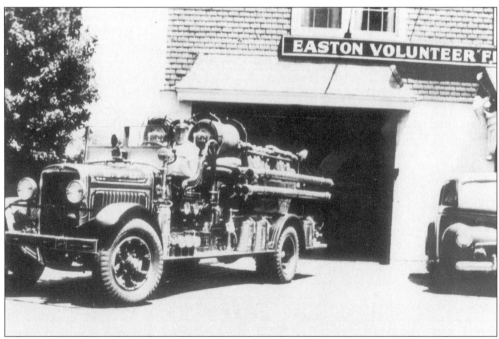

THE EASTON FIREHOUSE, 1937. Fireman Jim McQuaid poses at the wheel of the Easton Volunteer Fire Company's recently acquired Sanford engine. Chief Arthur Bush's car is on the right. After its formation, the fire company became an important social institution for many of Easton's men and later, for its women as well.

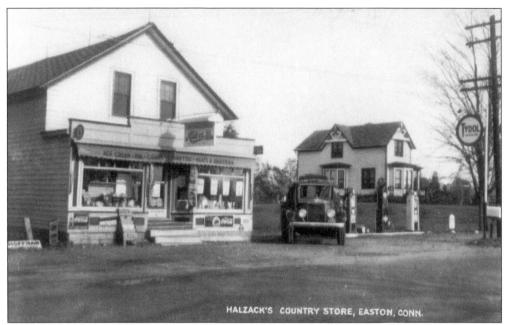

HALZACK'S COUNTRY STORE, EASTON, CONN.

HALZACK'S STORE, C. 1930. In 1923, George Halzack bought this property, which was originally the location of Horace Wheeler's blacksmith shop. Halzack converted the shop into a general store and gas station. Until the early 1950s, the shop even had a soda fountain. The Halzacks lived in the house on the right.

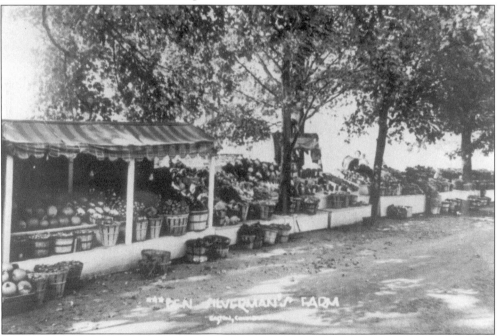

SILVERMAN'S FRUIT STAND, C. 1941. Ben Silverman was born in New York City in 1898 and came to Bridgeport *c.* 1916. He worked as a hired hand on several farms in Easton until he had saved enough money to buy property on the corner of Banks and Sport Hill Roads. In the late 1920s, he built this roadside stand, which was expanded into Silverman's Farm *c.* 1941.

37

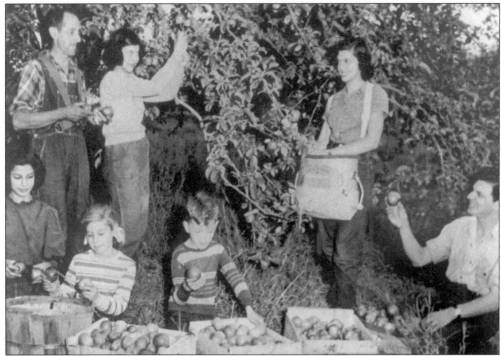

THE SILVERMAN FAMILY AT WORK, 1949. Silverman's farm was very much a family business. The Silvermans had six daughters and two sons. Working with Ben Silverman, who stands at the left, are from left to right: (front row) Pearl, Fran, Irving, and Harold; (back row) Janet and Adele. The farm and the store became an important part of the Easton Green community. After Silverman died in 1986, his youngest son, Irving Silverman, took over the business and modernized it.

EASTON CENTER, C. 1925. The intersection of Westport and Center Roads is the center of Easton's oldest community, existing since Easton became a parish in 1763. Easton Center is still dominated by the Congregational church, not shown in this view taken just in front of that edifice. Visible on the right is the Staples Academy, which at the time was a town consolidated school. After 1930, the academy building become the parish hall for the church.

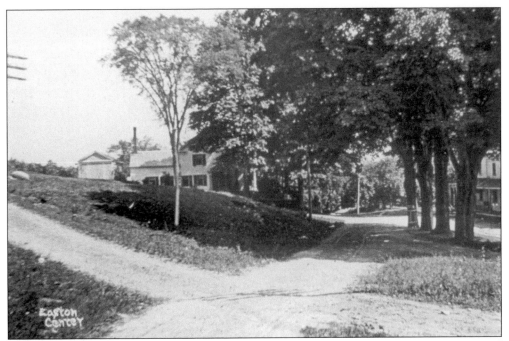

EASTON INTERSECTION, C. 1925. This photograph was taken looking east along Center Road at the intersection of Westport Road. The building on the right is the Ruhman Brothers store, which later became Grieser's General Store. This building became a store in 1870, when Henry Osborn moved the left section of the structure and joined it to the older, mid-18th-century right section.

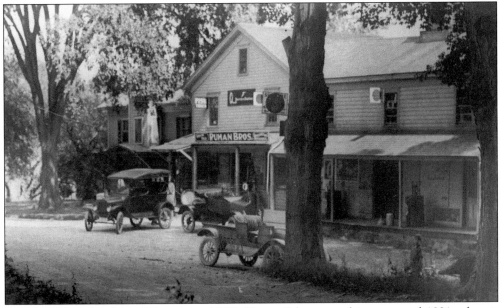

THE RUHMAN BROTHERS' STORE, C. 1925. Henry Osborn ran this store until 1921, when it was leased to the Ruhman Brothers. In 1928, the building was purchased by Richard Grieser Sr., and it has been run by a member of that family ever since. The ghost of Mrs. Osborn is said to appear on the porch of the house at the left.

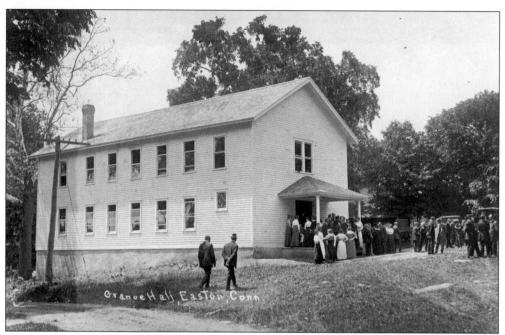

THE OLD GRANGE HALL, 1915. The Easton Grange was founded in 1897 and for the first 18 years, met at Loyalty Hall on Flat Rock Road and over Grieser's Store. This first grange building was located where the parking lot of the Congregational church is today. This photograph was taken during the dedication of the building, on June 2, 1915.

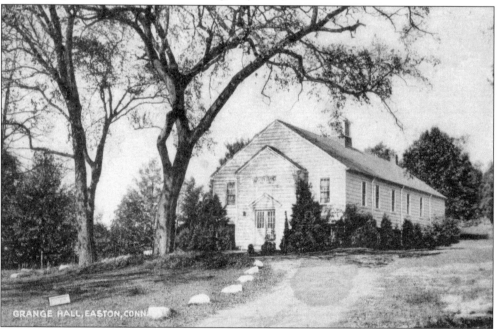

THE NEW GRANGE HALL, C. 1935. The old grange hall burned in a disastrous fire on December 6, 1931. This image shows the rebuilt hall, which is located farther to the east on Center Road, across from the town hall. The new grange hall was dedicated on August 31, 1933. This building became the Masonic Hall after the grange disbanded in 1967.

PLATTSVILLE, C. 1909. Plattsville was located at the junction of Congress Street and Sport Hill Road. It grew up around the store, the fulling mill, and the sawmill built by the Platt and Lacy families. This postcard view looks south across the Mill River bridge. Charlie Lacy's house, in the center, is actually in Fairfield.

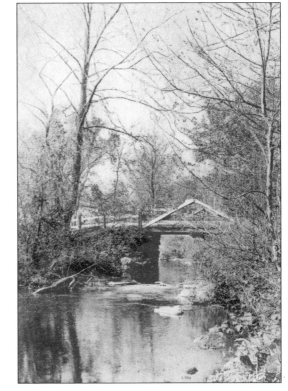

MILL RIVER BRIDGE, C. 1909. The rustic king-post truss bridge spans the Mill River, which forms the boundary between Fairfield and Easton at this point. The Sport Hill climb races started just to the left of this bridge and proceeded up the hill as far as Flat Rock Road. (See pages 124 and 125.) The abutments of this bridge can still be seen just to the west of the present concrete bridge across the river.

41

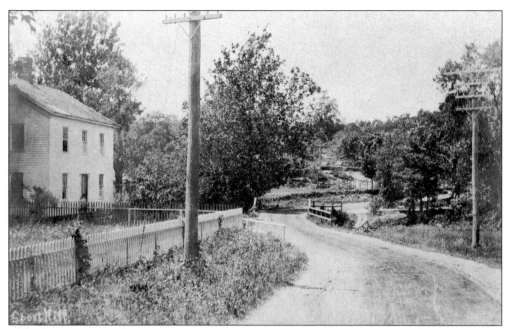

PLATTSVILLE, 1907. This view of Plattsville was taken from Fairfield, looking back into Easton. Most of the mills that led to the formation of this community were gone by the time of this photograph; however, there is still a post office, and buyers of milk and agricultural produce still came up from Bridgeport to purchase what Easton farmers had to offer. All of this now lies under the Merritt Parkway.

A LOWER SPORT HILL ROAD, C. 1915. Albert Hawkin begins the ascent of old Sport Hill Road, which ran around the base of these cliffs. In the early 1940s, there was a fatal automobile accident here, which led the state to reroute Sport Hill Road in a great arch to the east in 1945. For many years, a large star was lighted on the summit of this hill at Christmastime in memory of the accident victim.

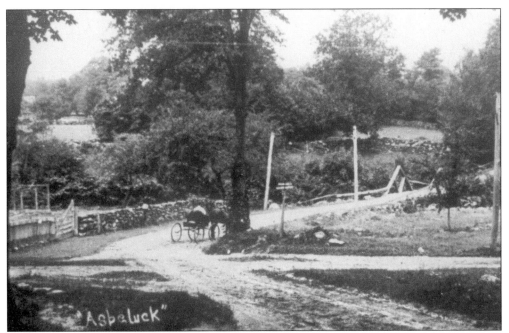

ASPETUCK CORNERS, C. 1905. Aspetuck Corners was the area around the triangle formed by Redding, Old Redding, and Westport (Route 136) Roads. This was one of the first areas to be settled in Easton because of the waterpower supplied by the Aspetuck River, over which the little bridge on the right passes. The wagon in the center has just come down Old Redding Road and is now headed into Weston.

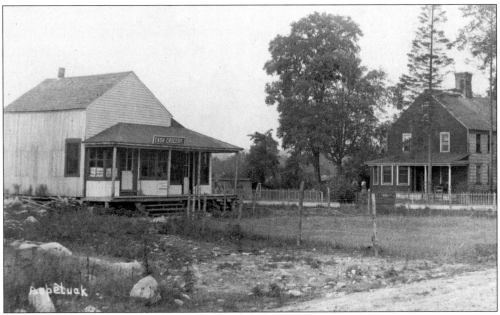

COMMUNITY STORE, 1908. Like most of the communities in Redding and Easton, Aspetuck Corners was served by a general store. The general store turned into a small cash grocery after the beginning of the 20th century. The store, shown on the left, opened in 1908 on Westport Road, just west of its junction with Old Redding Road.

43

ASPETUCK TRIANGLE, 1915. Florence Bradley Seaver stands by her automobile at the southern point of the Aspetuck Corners triangle. It was at this point during the Danbury Raid in 1777 that John Dimon and a neighbor were apprehended by a British scouting patrol returning from Lyons Plains. Dimon was taken to Danbury and back to New York, where he died on one of the prison ships there.

THE GUSTAVE PFEIFFER HOUSE, C. 1920. Gustave Pfeiffer fell in love with this house the first time that he saw it, in 1926. He subsequently bought it, along with 20 other houses in the area, which he restored and sold to his friends and acquaintances. In 1936, he built a house on the corner of Westport and Redding Roads. He gave that house to Helen Keller, who lived there until her death in 1968.

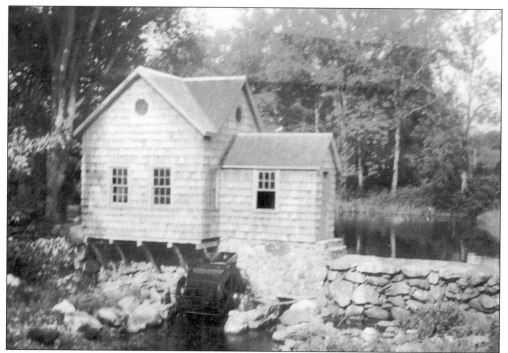

THE NEW ASPETUCK MILL, C. 1940. In 1934, Gustave Pfeiffer acquired the old Murwin Mill, which stood on Old Redding Road just below his house. (See page 53.) He promptly tore it down, rerouted the Aspetuck River slightly, and built this toy mill on his new dam. The waterwheel in the foreground does nothing but turn; however, it was a picturesque addition to Pfeiffer's village.

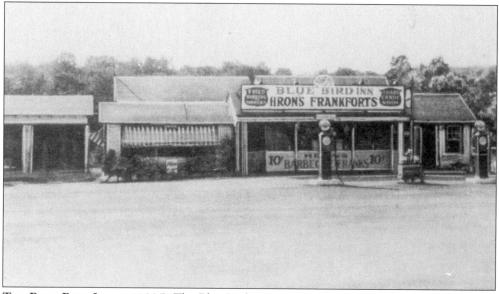

THE BLUE BIRD INN, C. 1935. The Blue Bird Inn was already a well-established refreshment stand on the corner of Redding Road and Black Rock Turnpike when this rival stand was built across the street. The rival stand also called itself the Blue Bird Inn. In self-defense the original stand took the new name of the Old Blue Bird Inn and survived its rival by many years.

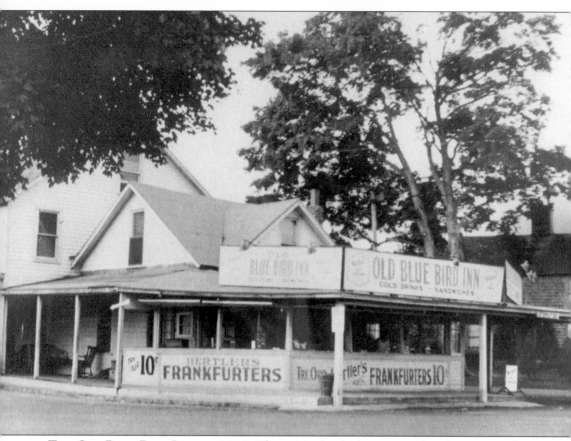

THE OLD BLUE BIRD INN, C. 1935. The original refreshment stand and restaurant has a new name: the Old Blue Bird Inn. Today, the establishment is still doing business, although the the intersection where it is located has been dramatically altered. This was the heart of Gilberttown, an area of Easton dominated by the Gilbert family. Gilberttown did not constitute a real community like the others shown in this work, since it did not have its own store and school. (It was part of the Aspetuck School District.) The name survives today only on the sign to the Gilberttown Cemetery, which lines the driveway to Toth Park. Some of Easton's most prominent citizens are buried in the cemetery, including Samuel Staples and several Revolutionary War heroes.

Three

REDDING AND EASTON'S ABORTED INDUSTRIAL REVOLUTION

THE MEEKER'S MILL, C. 1870. Originally located on Diamond Hill Road across from the Mark Twain Library, this gristmill was typical of the small support industries that provided the services that the normally self-sufficient farmers could not provide for themselves. Notice that power is being conveyed from the wheelhouse to the mill behind it by a long leather belt. The people standing in front of the mill are identified as the Selleck family.

THE WELLS'S BLACKSMITH SHOP, C. 1935. This undistinguished building, located on North Street in Easton, housed Tom Wells's blacksmith shop. Although a blacksmith shop is not considered an industry, it supplied a vital service to the local farmers and is therefore considered one of the support industries necessary in a farming community.

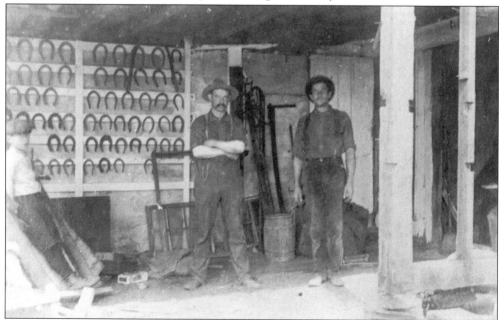

THE SHOP INTERIOR, C. 1915. Inside the Wells's Blacksmith Shop, from left to right, are Joe Busser, Tom Wells, and Abe Gordon. Other support industries expanded or turned into a successful factory or died out. The blacksmith shops continued in both towns until recently, because of the large horse population. However, the shops gave up the production of hardware in favor of larger factories located elsewhere.

48

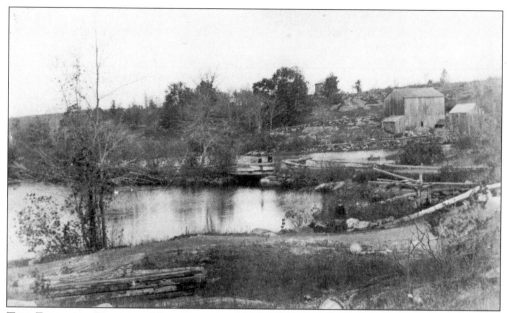

THE FOUNDRY DISTRICT MILLPOND, C. 1905. The Foundry District in southern Poverty Hollow was one of the only areas that almost developed a successful industry: James Sanford's foundry, which operated from 1824 until 1862. The millpond here at the base of Meeker Hill supplied waterpower to a series of mills and button and comb shops that were arranged along the river from Meeker Hill Road south for several hundred yards.

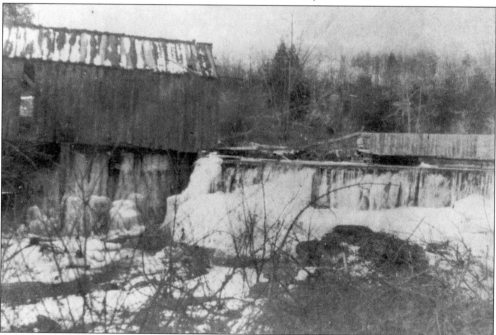

THE FOUNDRY DISTRICT SAWMILL, C. 1910. The first mill to draw water from the above pond was this sawmill located at the base of Meeker Hill, just to the west of the bridge. The bridge has been rebuilt and relocated, but part of the foundation of the old mill can still be seen to the south of the road, just before the bridge.

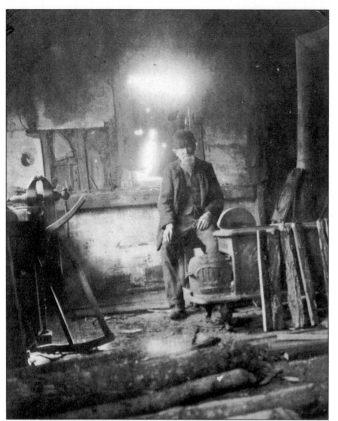

THE SAWMILL INTERIOR, C. 1910. This is a rare interior view of the old sawmill pictured on the previous page. In the corner that served as a workshop, a man appears to be cutting wood for the stove. The working machinery of the mill is not shown.

THE SANFORD BUTTON SHOP, C. 1910. This is the only known photograph of one of the three button and comb shops that were built along the river. This is the most northerly one, located just 100 yard south of the dam. The button industry flourished here between 1862 and the beginning of the 20th century, but it could not survive the competition of the urban factories, which used steam engines to drive their machines.

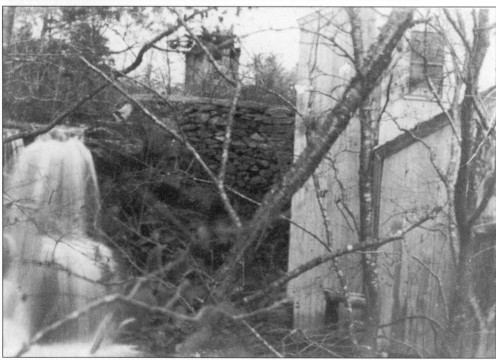

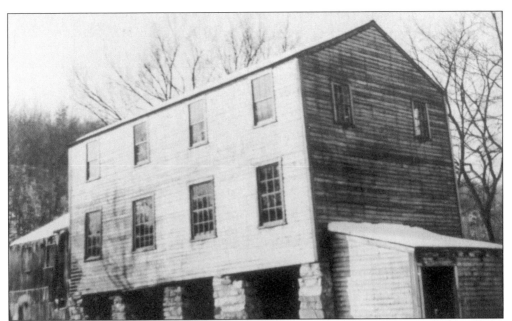

THE MILL OF MYSTERY, C. 1919. This structure was located on the Saugatuck River, a few hundred yards north of the Diamond Hill Road Bridge. It is probably a sawmill, but its identity and use remain elusive. The picture comes from the 1919 photographic survey of all property owned by the Bridgeport Hydraulic Company. In that inventory the building is identified simply as a mill, with no further information given.

WILSON AND BARTRAM, CARRIAGE MAKERS, 1890. Ebenezer Wilson stands in front of his house on Newtown Turnpike, just south of Sanfordtown Road. Wilson's wife sits in one of the carriages that he made in the carriage shop located across the road from the house. Local carriage making died out after the Civil War, unable to meet the competition of the larger urban carriage shops.

THE OLD GEORGETOWN GRISTMILL, C. 1905. This mill, which was actually located on Old Mill Road in Wilton, served a succession of owners, none of whom remained in business for long. It began *c.* 1850 as a woolen or satinet mill. (Satinet is a mixture of wool and cotton.) The mill continued under a succession of owners until Dr. Perry turned it into a gristmill for medicinal herbs at the beginning of the 20th century.

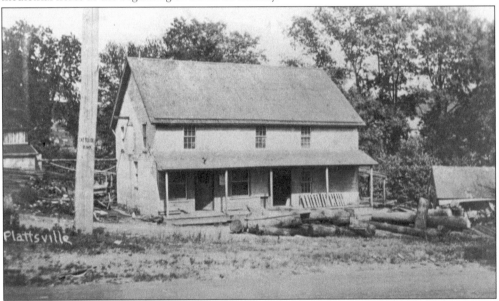

THE PLATT SAWMILL, 1910. This mill was one of several around which the Plattsville community developed. It was located at the base of Sport Hill Road, to the east of the bridge that spanned the Mill River. Just after World War II, when Sport Hill Road was rebuilt and moved several yards to the east, the building was destroyed; however, it had ceased to function as a sawmill many years earlier.

52

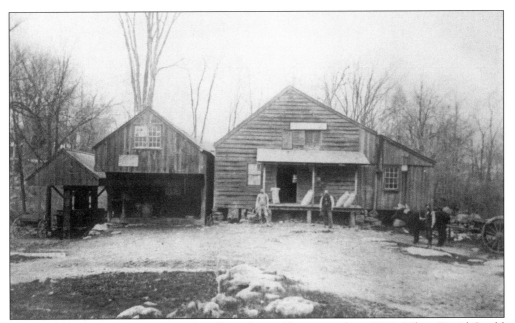

GOULD'S ASPETUCK MILL, 1874. A mill was located here as early as 1710. When David Gould owned it, the mill was used to grind grain and to make cider. Gould also kept a store in the main building. In 1891, he sold the complex to Berton Merwin. The following year the mill was struck by lightning and it caught fire and burned.

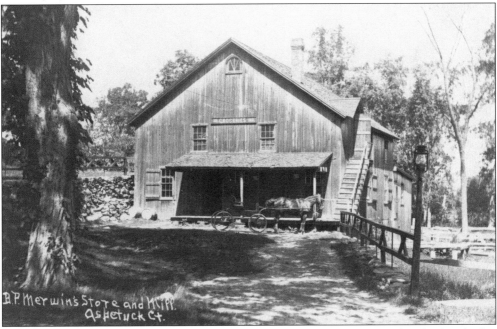

MERWIN'S ASPETUCK MILL, C. 1910. Berton Merwin rebuilt the mill immediately after the fire of 1892 and used it to make cider. The processed flour that became available at the beginning of the 20th century doomed local gristmills. In 1898, Merwin began to make wooden toys in the upper story. These toys proved very popular and his business flourished until the beginning of the Great Depression in 1931, when Merwin went bankrupt.

THE GILBERT MILL, 1919. This mill was used as a cider mill, although recent archaeology has shown that it was originally a sawmill. Located on Tatatuck Brook, just south of the bend in Everett Road, the Bridgeport Hydraulic Company acquired the property shortly before the beginning of the 20th century because it stood on watershed for the future Easton Reservoir. The mill was torn down shortly after this photograph was taken.

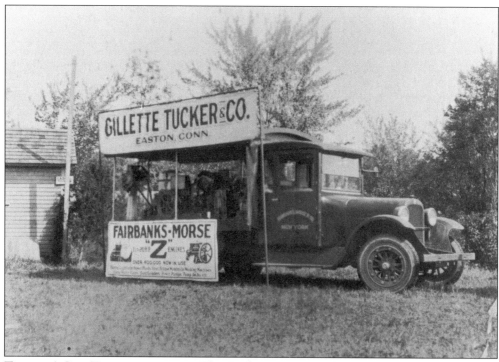

TUCKERS' GAS ENGINES, C. 1930. The Tucker twins, Arthur and Henry, did business on Center Road as the Tucker Machine Company between 1927 and c. 1938 and were the local agents for Fairbanks gas engines. These gas engines began to replace waterpower. Sawmills were no longer tied to a stream or river and could be set up near a convenient source of wood. The era of the mill had come to an end.

Four

GILBERT & BENNETT
AND GEORGETOWN:
INDUSTRIAL SUCCESS

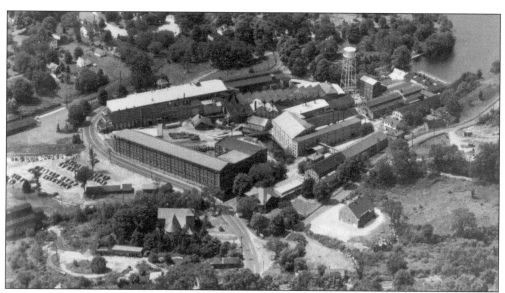

GILBERT AND BENNETT FROM THE AIR, C. 1940. The reason for Georgetown's existence is the Gilbert and Bennett wire mills. Of all the businesses started in the 19th century in both Redding and Easton, this was the only one to survive into the 20th century. The secret of its success was the railroad that went right by its various factories and even went into the center yard of the upper factories, as shown here. This reduced transportation costs to the point where manufacturing wire cloth was profitable.

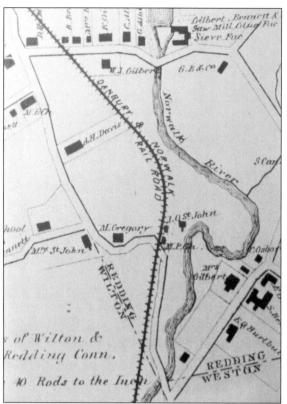

A MAP OF THE UPPER FACTORY, 1867. This map of the Redding section of Georgetown shows the upper factory as it appeared just after the Civil War. (See the upper right corner.) The company got its start in the complex of buildings below the bend in the Norwalk River in 1818. (See the lower right corner.) Later in the century, the upper factory expanded, forcing the town to reroute Main Street, which had already been diverted slightly here.

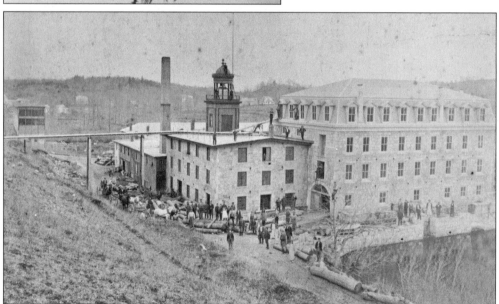

THE OLD UPPER FACTORY, C. 1870. This formal portrait of the upper factory shows a sawmill and glue and sieve production facilities. Note that all of the employees are standing in front of and on the various parts of the building, including on top of the chimney at the peak of the center roof. This pose was typical of mid-century industrial photographs. The factory was destroyed by fire on May 11, 1874.

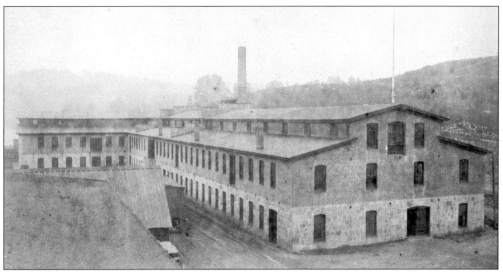

THE NEW UPPER FACTORY, C. 1890. The charred remains of the old factory were quickly replaced with this new upper factory. The tall chimney stack is all that remains of the original building. This plant became the nucleus of the factory complex shown at the beginning of this chapter. Along with rebuilding the factory, Gilbert and Bennett also reorganized in 1874 as an incorporated stock company, with most of the stock being held by the Gilbert family.

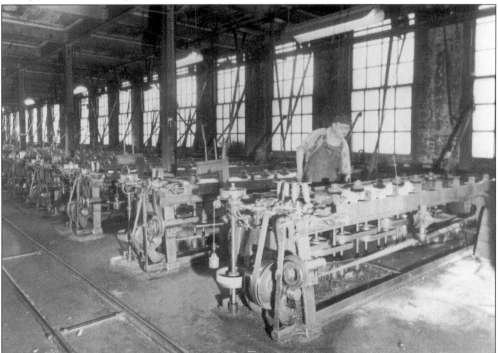

MANUFACTURING WIRE CLOTH, C. 1950. John Huajanen operates a fine wire drawing machine in the upper factory. The wire is drawn through diamond dies and drawn to the gauge of window screening. It is then loomed into mesh and electrogalvinized. Gilbert and Bennett invented wire insect screening in 1861, when the Civil War eliminated the market for wire fencing in the South.

57

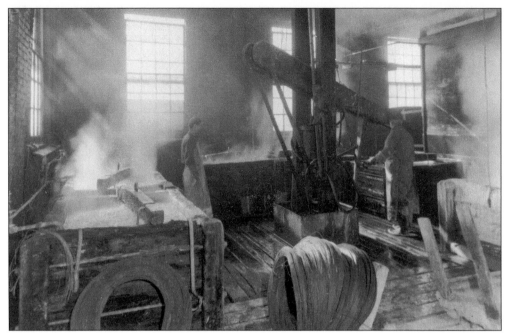

ROD CLEANING ROOM, C. 1940. In the Rod Cleaning Room, 150-pound coils of wire are suspended by a wooden crane that is operated by hand-pulled ropes. These coils are dipped in sulfuric or muriatic acid to remove oil, scale, and rust. They are then moved to a water bath, dipped in a lime solution, and placed in a baker to dry.

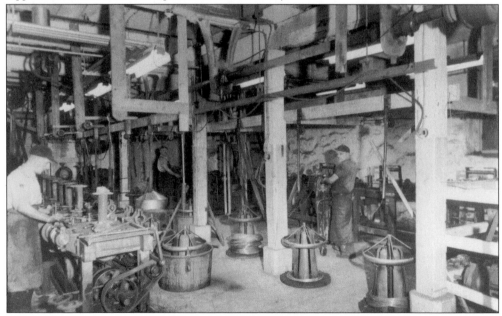

SPOOLING WIRE, C. 1940. Skein wire is shown here, wound onto spools from cones, preparatory to moving to the loom for weaving. To the right is Sam DiFranco, and to the left is an employee who is identified only as John "the Polak." As Gilbert and Bennett expanded at the end of the 19th century, it began hiring large numbers of immigrants from Eastern Europe and Scandinavia.

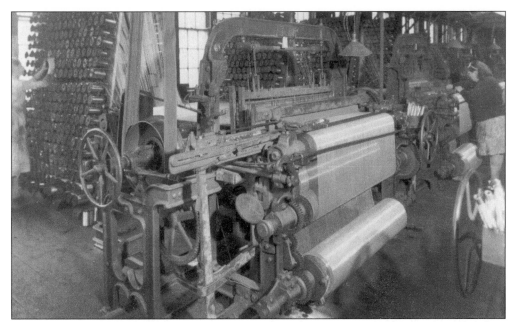

WEAVING MACHINE, C. 1940. In what was known as "the Girls' Building," wire was woven into wire cloth. Each woman operated a weaving machine and was paid by the number of feet of finished wire cloth she produced. Splicing the wire of the warp, left, was done by twisting wire from a new spool onto the remnants of the old spool by hand when it was about to run out.

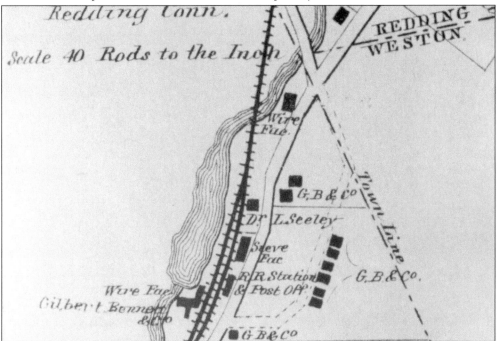

MAP OF THE LOWER FACTORIES, 1867. The lower factories, now gone, were located in the Wilton section of Georgetown, along what is known today as Old Mill Road. The wire factory at the top of the map is the Old Red Mill. Toward the bottom of the map are the sieve factory, the Georgetown railroad station and post office, and the lower wire factory.

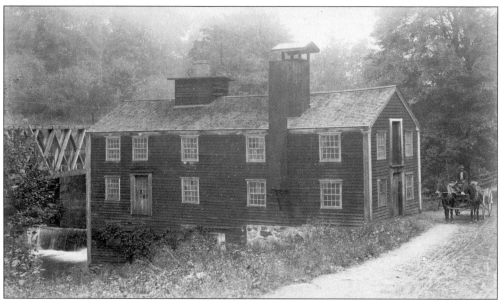

THE OLD RED MILL, C. 1888. In 1834, Gilbert and Bennett built their second factory on the Norwalk River. (The first was on the corner of Route 57 and Old Mill Road, where Connery Brothers did business for many years.) The first floor was used to process curled hair; in the basement, sieve rims were steamed and bent into shape. This building burned on May 10, 1889.

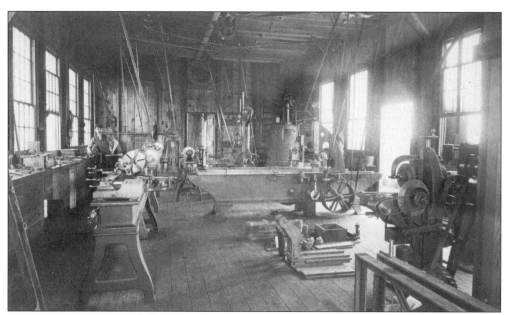

THE MILL INTERIOR, C. 1888. This image appears to be a rare interior view of the Old Red Mill. It is not known what was produced on these machines. Notice the exposed leather belts that connect each machine to the drive shaft just under the ceiling. This arrangement was typical of 19th-century mills and factories; it was extremely dangerous, especially for women who had long hair.

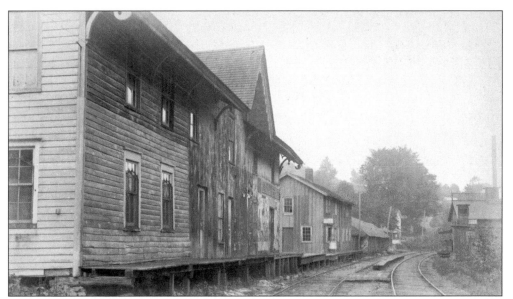

THE LOWER FACTORIES, C. 1890. On the left is the old sieve factory, with the Georgetown railroad station and post office just beyond. To the right of the tracks is the lower wire drawing factory. In addition to wire insect screening, Gilbert and Bennett is noted for its invention of hex mesh poultry fencing in 1865.

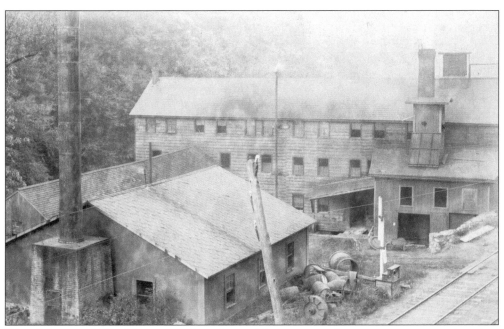

WIRE MILL, C. 1890. The tremendous demand for iron wire for insect screening and poultry fencing created the need for a local wire mill. In 1863, this mill was constructed just downriver from the Old Red Mill. Produced here were the raw material for other new Gilbert and Bennett products, such as cheese and meat safes, coal screens, and ox muzzles.

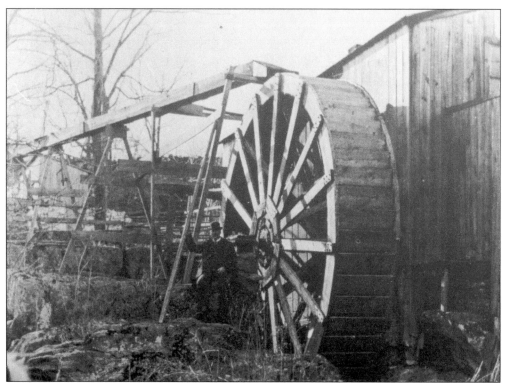

THE LOWER WATERWHEEL, C. 1890. To power the wire mill, a new dam was constructed that created the lower millpond and this overshot waterwheel was put into place. Today, all of the lower factories and the dam are gone; only a few foundations and the dam abutments remain. All of Gilbert and Bennett's production facilities were consolidated in the upper factories.

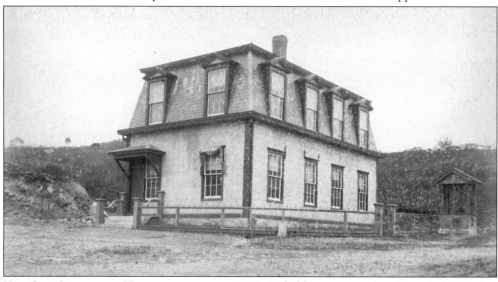

THE OLD CORPORATE HEADQUARTERS, C. 1890. Probably constructed in the early 1870s, this building served the managerial needs of Gilbert and Bennett for about 25 years. Its construction was unique for the time. To the outside of the building's framework, wire mesh or lath was stapled. The mesh was then coated with cement, which was worked to look like stone.

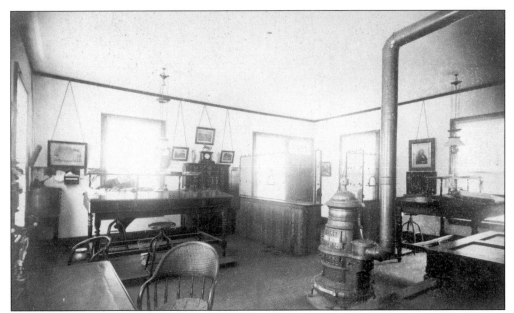

THE OLD CORPORATE HEADQUARTERS, C. 1890. This rare view of the interior of the old headquarters shows the main reception area of the building. Like the outside, wire mesh or lath was stapled to the inside of the wood frame and was then coated with plaster. This was the first time that metal lath was ever used.

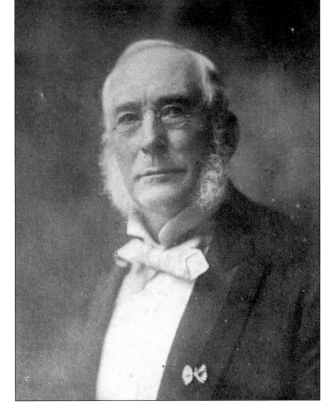

EDWIN GILBERT, C. 1900. Edwin Gilbert joined the firm in 1844. When the company incorporated in 1874, he became one of the members of the first board of directors. Gilbert subsequently served as president and treasurer from 1884 until his death in 1906. He was responsible for weathering the severe depression of 1893 and for bringing the company into the 20th century as a modern production facility.

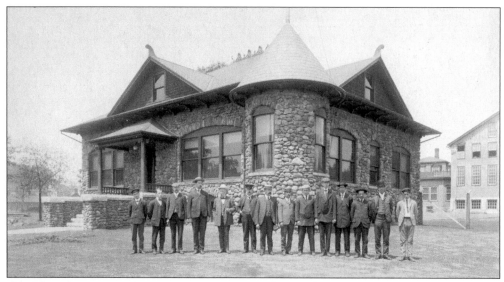

THE NEW CORPORATE HEADQUARTERS, 1906. This building was the last that Edwin Gilbert saw completed before his death. It was constructed in 1906. This photograph was taken to commemorate the opening of the new building, with the officers and staff posing in front. Edwin Gilbert is standing fifth from the left and Samuel Miller, who later become president, is standing seventh from the left. The others are unidentified.

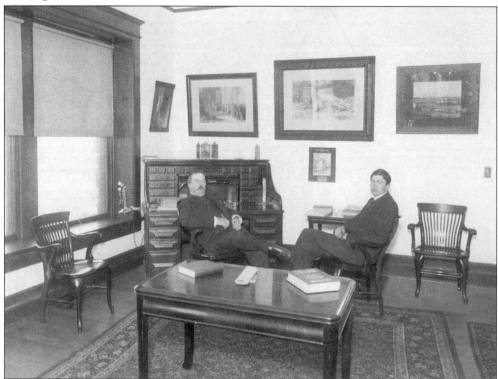

AN OFFICE INSIDE CORPORATE HEADQUARTERS, 1906. This photograph shows what appears to be the office of the vice president-secretary of the company. Samuel Miller, who was serving in that capacity at the time, sits at the desk. The man on the right is unidentified.

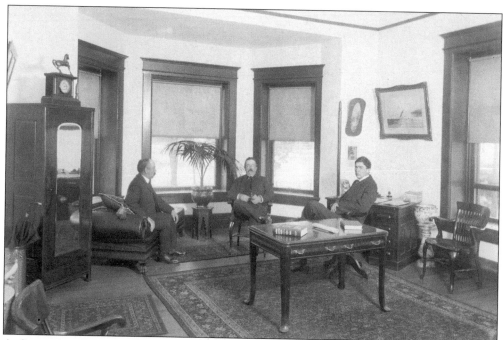

A SPACIOUS OFFICE, 1906. This view shows the other end of the office pictured in the previous photograph. Samuel Miller is sitting in the center. He joined the company in 1869 as an office boy and climbed all the way up the corporate ladder, becoming president in 1915. He remained president until his death in 1936.

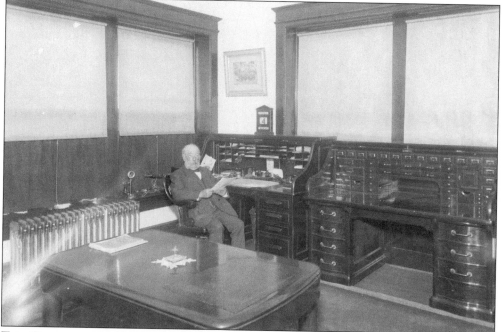

THE OFFICE OF THE PRESIDENT, 1906. This is the office of the president, showing Edwin Gilbert just a few months before his death. The calendar on the desk indicates that this photograph was taken on Monday, June 4, 1906.

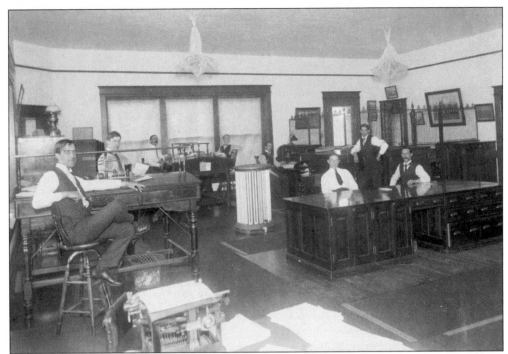

THE MAIN ROOM, 1906. This photograph shows the main room and recreation area of the new headquarters building just after it opened. Note the early typewriter in the foreground.

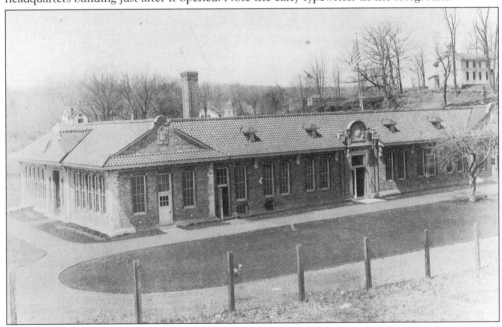

THE GILBERT AND BENNETT SCHOOL, C. 1916. Feeling the need for a school that could accommodate the growing school-age population of its employees, Gilbert and Bennett built this school and deeded it to District No. 10. The old school, which burned in the late 1920s, can be seen in the background. When the district school system was completely abolished in 1964, the school was deeded to the town of Wilton.

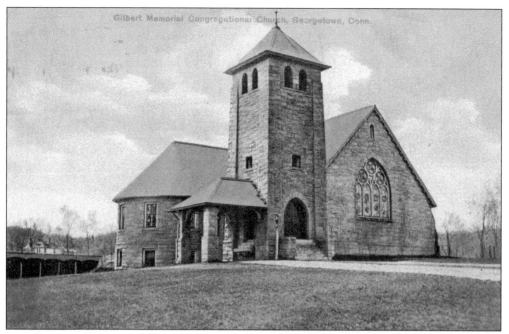

THE GILBERT MEMORIAL CHURCH, C. 1910. Another gift to the community was the Gilbert Memorial Congregational Church; it was built in 1901 while Edwin Gilbert was president. The church disassociated itself from the established Congregational Association in the 1940s and on April 7, 1965, became the Georgetown Bible Baptist Church.

THE GILBERT AND BENNETT RESIDENCES, C. 1910. Company employees lived in different areas of Georgetown. This photograph of North Main Street, to the west of the upper factories, shows the houses of the company's managers and owners. The workers lived on the north side of the millpond, along what is now Portland Avenue.

THE COMPANY RESIDENCES, C. 1910. Somewhat more modest dwellings were built along Smith Street, to the south of the managers' residences. These houses were built by the company's more affluent employees, and this postcard shows the street in its early stage of development. After World War II, Route 107 was cut across the southern end of this street, removing the nearest house in the upper photograph.

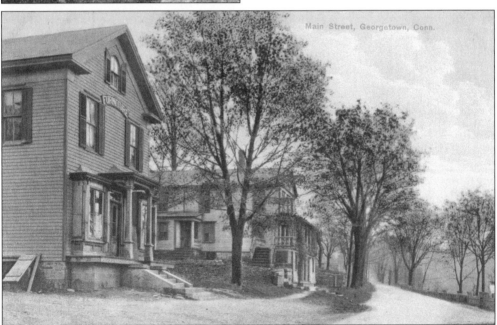

ESSENTIAL SERVICES FOR GEORGETOWN, C. 1910. The community of workers that grew up around the upper factory produced the need for stores and other services. This postcard shows Main Street (now the northern end of Old Mill Road) as it looked shortly after the beginning of the 20th century. The building on the left contained a furniture store in its upper story and a general store on the main floor.

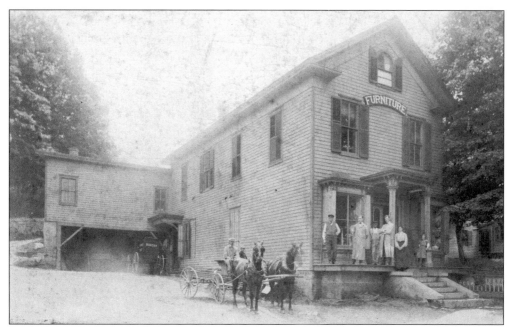

CONNERY'S STORE, C. 1900. This photograph shows the furniture and general store on Main Street, with the entrance to a bakery at the rear. The baker's wagon stands ready for loading, just outside his door. This building stood on the site of the first Gilbert and Bennett factory called the Old Red Shop. By the time of this photograph, it was known as Connery's Store.

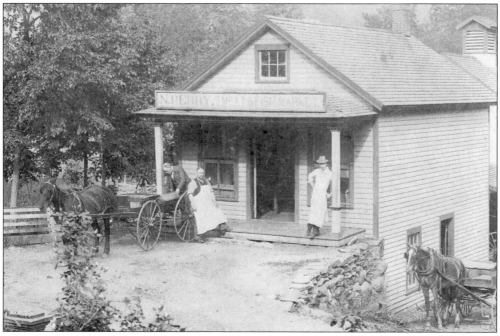

PERRY'S MARKET, C. 1900. Nathan Perry's Meat and Fish Market also served the Gilbert and Bennett community. On the right is a meat wagon, which made a circuit around the community three or four times a week, selling fresh meat and fish directly to waiting housewives. This building stands where the Redding Pilot offices are now located.

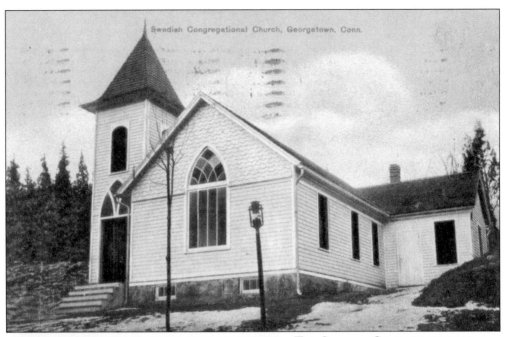

Swedish Congregational Church, Georgetown, Conn.

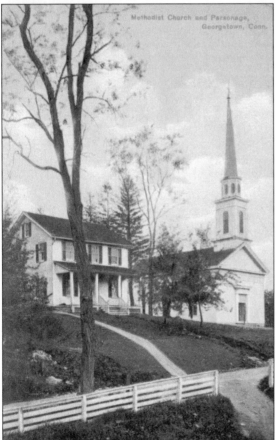

Methodist Church and Parsonage, Georgetown, Conn.

THE SWEDISH CONGREGATIONAL CHURCH, C. 1930. Several churches served the spiritual needs of Gilbert and Bennett employees. The Swedish Congregational Church on the Old Weston Road (now Covenant Avenue) ministered to the predominantly Protestant Scandinavian workers. The church was founded in 1889, and this building was constructed in 1891. The building is now a private residence.

THE METHODIST CHURCH, C. 1925. The Methodist church and its parsonage served a more Yankee portion of the community's population. The church building shown here was constructed in 1857 and still stands on Church Street. Reverend Tranner, upon his installation as pastor, sent a friend this postcard showing his new residence.

Five

EDUCATING THE YOUTH OF REDDING AND EASTON

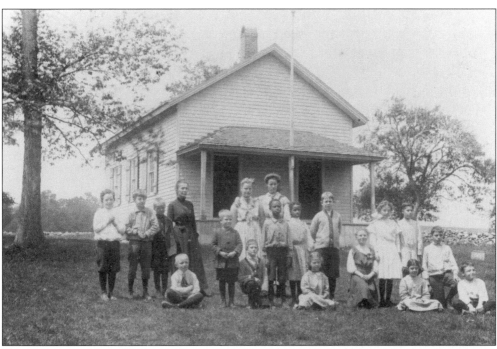

THE REDDING RIDGE DISTRICT SCHOOL, 1910. From the late 18th century until the 1920s, education was primarily supplied by local school districts that maintained the one-room schoolhouses that were a ubiquitous feature of the town's landscape. This schoolhouse was located on Black Rock Turnpike, just across from Meeker Hill Road. The teacher was Jeannie McDonald, and the students came from the Banks, Burr, Riley, Rumsey, and McCollam families. This building is now a private residence.

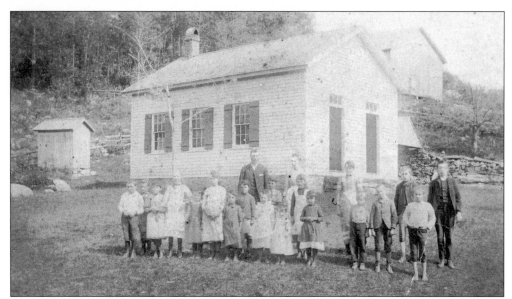

THE FOUNDRY DISTRICT SCHOOL, C. 1900. This little schoolhouse, with its separate entrances for boys and girls, stood on the corner of Foundry and Stepney Roads. Although schoolteachers were predominantly women, it was not unusual for a young man to teach for a year or two before launching off on another career, as was probably the case here. Today, this building is a private residence.

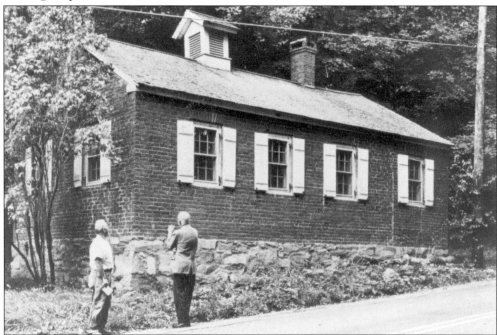

THE UMPAWAUG SCHOOL, 1963. The first mention of a school on this spot was in 1789. Although the district was dissolved in 1910, classes continued to be held here until 1929. To the left is William W. Ryder, who attended this school and was involved in its restoration under the aegis of the Redding Historical Society in 1965. This photograph was taken by the famed photographer and longtime Redding resident Edward J. Steichen.

THE INTERIOR OF THE UMPAWAUG SCHOOL, 1963. This Edward J. Steichen photograph shows the interior of the school through its entrance, just before the building was restored by the Redding Historical Society. An earlier restoration was done by the Women's Civic Club in 1938. This school is almost unique in that it was built of brick. The building's construction and its use as a school as late as in 1929 account for its survival.

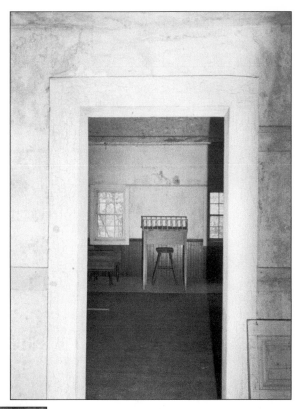

THE FRONT OF THE UMPAWAUG SCHOOL, 1963. This impressionistic photograph, taken of the front entrance by Edward J. Steichen, highlights the need for restoration. Redding was fortunate to have this noted photographer as a resident and an involved citizen. He chronicled the town's late-20th-century history with his photographs, many of which are unpublished and unknown outside of Redding.

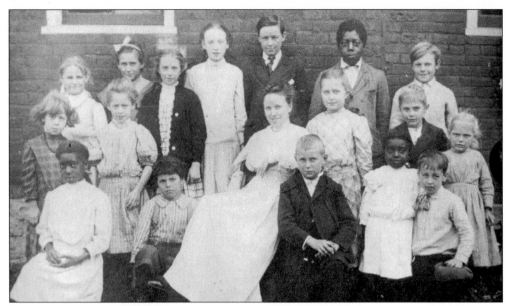

STUDENTS OF THE UMPAWAUG SCHOOL, C. 1910. This typical selection of students was photographed at about the time that the school district was dissolved. The teacher was Minnie Lou Carson, and the students represent the Curtis, Ryder, Stietzel, and Jennings families, among others. Note the presence of Viola and Miles Curtis, members of one of Redding's African-American families. The integration of races in the rural towns of Redding and Easton was not questioned in the late 19th century.

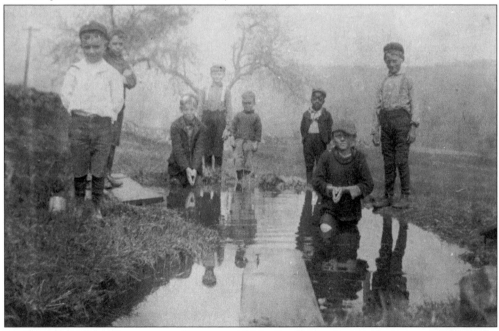

IN BACK OF THE UMPAWAUG SCHOOL, 1906. Students play in the stream behind the Umpawaug School during one of the daily recesses. In the picture are Howard Light, Miles Curtis, Clair Hill, William Ryder (who later helped restore the school), Eben Hill, Ed Babcock, John Carson, and Henry Carroll.

74

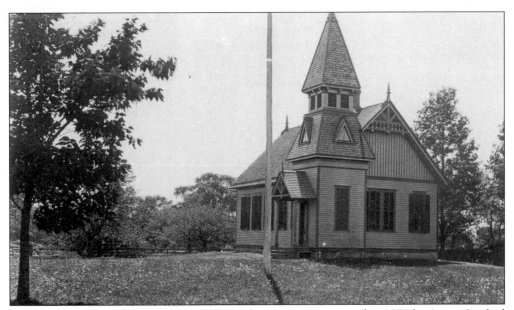

THE HILL ACADEMY, C. 1900. The Hill Academy was incorporated in 1878 by Aaron Sanford Hill as one of several academies in Redding that served the needs of students for secondary education before high schools became widespread. This building, which stood on Lonetown Road (Route 107) where the town hall is now, was built in 1883 and is a superb example of the stick style of Victorian architecture.

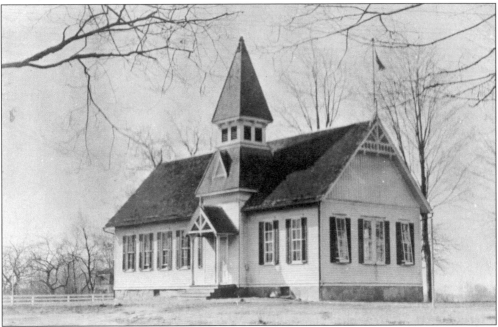

THE HILL SCHOOL, C. 1930. This photograph shows the school with a modest addition to the south. The addition was constructed about the time that the building was transferred to the town to be used as a consolidated school, taking the place of the town's many district schools, which were being closed. In 1959, this building was completely renovated and became the town hall. It has recently undergone further renovation.

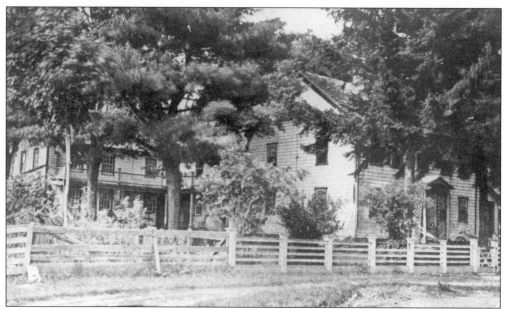

SELLICK'S BOARDING SCHOOL FOR GIRLS, C. 1910. Originally built *c.* 1760 by Isaac Meeker, this house became the site of a successful girls' school. Polly Sellick founded Sellick's Boarding School for Girls here in 1844. The students were housed in the wing on the left (now gone). Educational opportunities for girls were very rare in the mid-19th century, which makes this school unusual and remarkably progressive. This house still stands on the corner of Great Pasture Road and Route 53.

THE REDDING INSTITUTE, C. 1910. Redding has always been known for its educational institutions. Throughout the 19th century, it maintained an unusually large number of academies that supplied secondary education to prepare boys for the university (usually Yale). The Redding Institute was opened in the fall of 1847 by Daniel Sanford; it was located on Redding Ridge at 153 Black Rock Turnpike, just south of Cross Highway.

THE OUTBUILDING, C. 1895. This view of the Redding Institute shows the outbuilding on the left (now gone) that served as the actual school. Under Daniel Sanford's guidance, the institute achieved a national reputation that continued under Sanford's successor, Edward P. Shaw. The institution was closed in 1873 as a result of several tragedies in Shaw's family; Shaw continued to live in Redding until 1904.

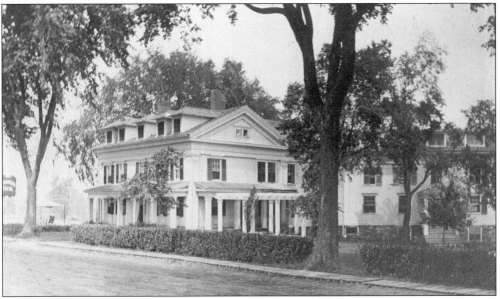

THE SANFORD SCHOOL, C. 1910. Daniel Sanford's son Daniel worked to resurrect his father's institute in this building on Black Rock Turnpike, just north of Cross Highway. It was opened in the fall of 1905 and offered courses in agriculture, as well as the usual academic fare. The school maintained a full-working farm as part of its agricultural program. The dormitory and classroom wing can be seen to the right of the main building.

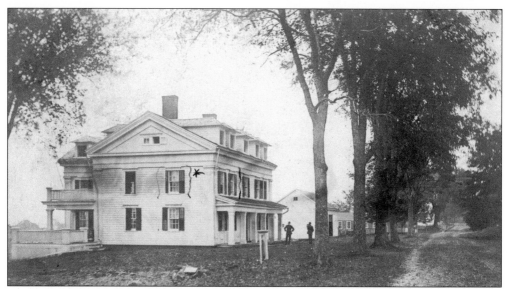

THE RIDGEWOLD INN, 1907. During the winter, this building served as the Sanford School. During the summer, with the boys on vacation, the building became the Ridgewold Inn, housing city dwellers who wanted to escape to the country for a week or two. This postcard was sent in 1907 by one of the Ridgewold's denizens who marked the room in which he stayed with a star.

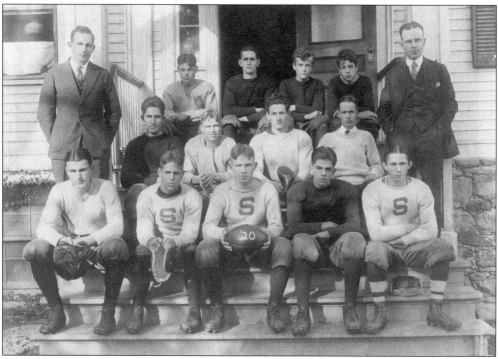

THE SANFORD FOOTBALL SQUAD, 1920. This formidable group of young men poses at the end of the 1920 season. Standing to the left and right are teacher-coaches Mr. Ballenkin and Mr. Mahan, respectively. The young man at the front left is Howard Burr, who continued to live on Redding Ridge until recently. The success of this team has gone unrecorded.

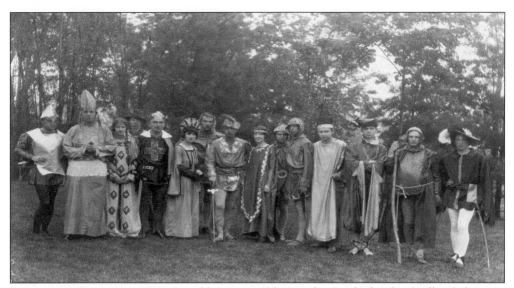

DRAMA AT SANFORD, 1920. In addition to athletics, the Sanford School offered thespian opportunities. The cast of the play *Robin Hood* poses in full regalia. Actor Cesar Romero attended the Sanford School, but it does not appear that he made the cast of this play. When the school closed in the late 1920s, the main building was cut into thirds. Two sections were moved down onto Church Hill Road, where they became private residences.

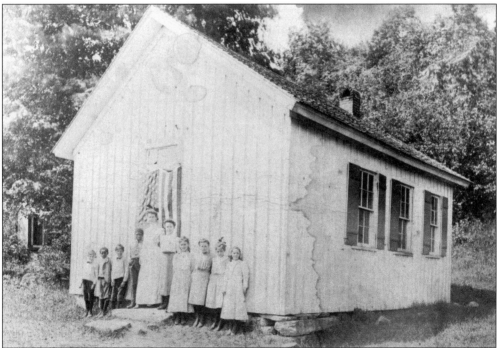

THE WILSON SCHOOL, C. 1910. Like Redding, education in Easton in the 19th and early 20th century was dominated by the ubiquitous one-room schoolhouse. The Wilson School stood on Black Rock Turnpike, across from the entrance to Silver Hill Road. The teacher was Marilla Rockwell, and the two black children may have been from the Baldwin family, who lived on Den Road near the Redding border.

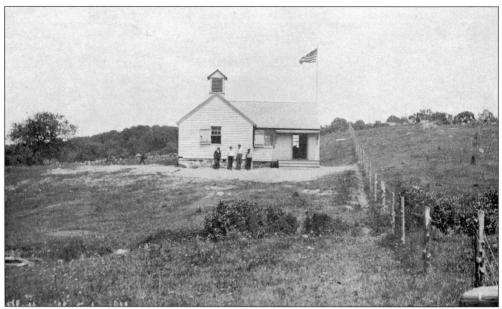

THE PLATTSVILLE SCHOOL, C. 1910. The Plattsville School, located on the corner of Jefferson Street and Sport Hill Road, had at least two rooms. This school was actually situated in Fairfield; however, children living in southeastern Easton attended here. This arrangement, similar to that in many of the border communities, was made possible because the money to run the school came from the district rather than from the town.

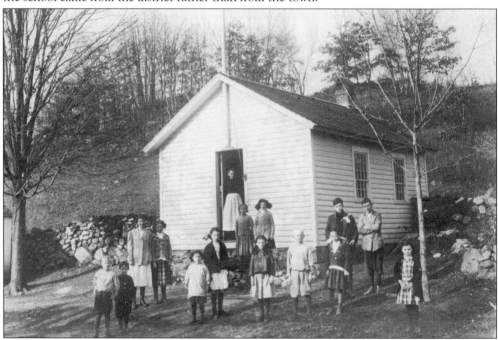

THE JUDD SCHOOL, C. 1910. Located in another frontier area of Easton, the Judd School served the extreme northeast area of the town. This area was originally part of Stratford rather than Fairfield, as was most of the rest of the town. The building was situated on the corner of Judd Road and North Street. Posing outside the school are teacher Miss Davis and her pupils.

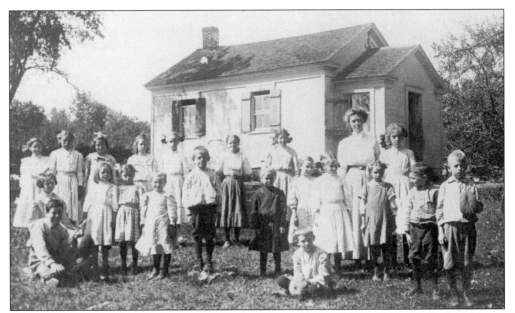

THE CENTER SCHOOL, C. 1910. This school was one of Easton's first, although the building, as it appears here, was rebuilt near the beginning of the 20th century. At that time the entrance was moved from the side of the building (its original 18th-century position) to the gable end and an entrance foyer was added. The school stood across from the historical society's restored Adams School on Westport Road, south of Center Road.

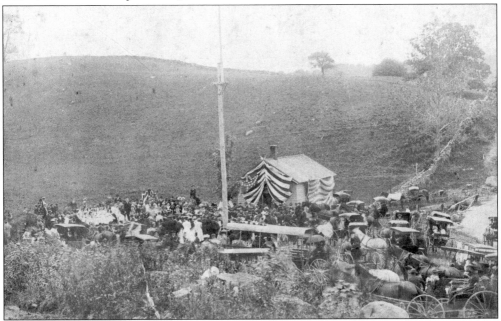

THE DUGWAY SCHOOL, C. 1900. District School No. 3, or the Dugway School, was located on the corner of Old Oak Road and North Park Avenue, under what is now the Easton Reservoir. This rare photograph shows a large crowd of Easton citizens in their Sunday-best clothes, attending what appears to be a Fourth of July celebration. Ironically, there is no flag on the flagpole.

THE ADAMS SCHOOL, C. 1910. This postcard view shows the Adams School in its original location on the northeast corner of Adams and Sport Hill Road. It was built in 1854, replacing an earlier structure. Note the privy peeking around the corner of the building. The privy was almost always left out of early schoolhouse photographs, but it was a necessary feature of the schoolhouse grounds.

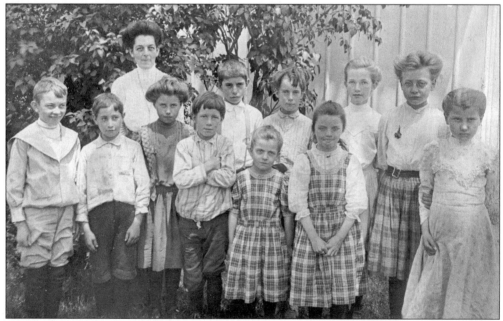

A CLASS AT THE ADAMS SCHOOL, C. 1910. This class was presided over by Lucy Sanford and contained members of the Gilbert, Andrews, and McCollum families. When the school closed in 1919, the building was moved to the front lawn of Samuel Senior's house on lower Sport Hill Road. The Historical Society of Easton was formed in 1968 to move the school to its present location on Westport Road and to restore it.

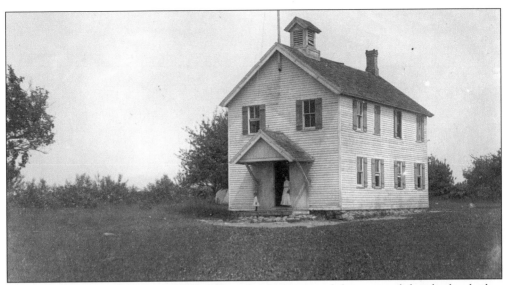

THE SPORT HILL SCHOOL, C. 1900. This school was one of three consolidated schools that operated in Easton from 1900 until the building of the Samuel Staples Elementary School in 1930. The Sport Hill School was constructed in 1897. After it was closed, the building was converted into a private residence, which still stands at 35 Flat Rock Road. The consolidated schools served as central educational facilities as the district schools began to close.

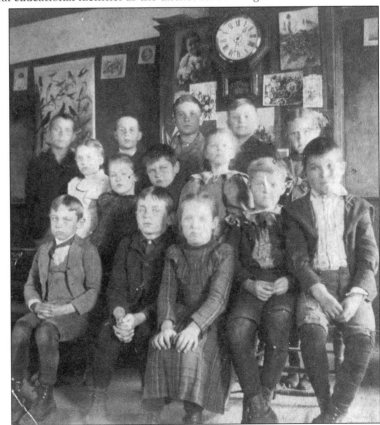

A CLASS AT THE SPORT HILL SCHOOL, C. 1900. Interior photographs of the consolidated school are rare. This one shows the wall with a clock and bulletin board decorations, which were typical at the time. The class consisted of members of the Marsh, Allen, and Smith families. In the middle of the 20th century, the Marshes were known for their dairy, which supplied most of southern Easton with milk until the late 1950s.

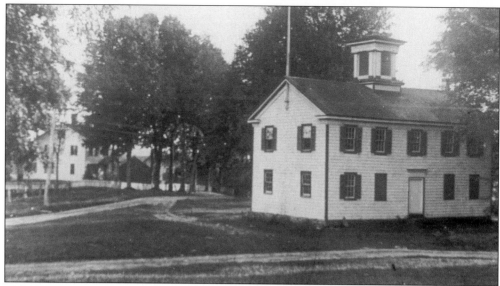

THE STAPLES ACADEMY, C. 1910. This view of the intersection of Westport and Center Roads shows the rear of the academy building. When this photograph was taken, the building was serving as another of Easton's consolidated schools. It was constructed for the Staples Free Academy in 1795, making it the oldest public building in either town.

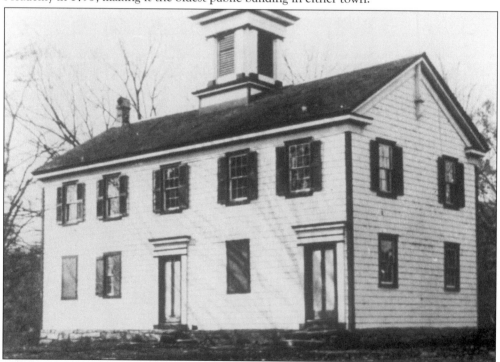

FRONT VIEW OF THE ACADEMY, C. 1910. The Staples Free Academy failed in 1902, and the building was turned over to the town to serve as a consolidated school until 1930. Easton held its town meetings in this building from the time of its incorporation in 1845 until 1912. Even before that time, the building was frequently the site of town meetings for the town of Weston, of which Easton was part until 1845.

84

INTERIOR VIEW OF THE ACADEMY, C. 1917. This rare interior view shows an academy classroom sometime around Thanksgiving. The picture on the wall of Pres. Woodrow Wilson dates this photograph to *c.* 1917. In 1937, the building was turned over to the Congregational church, which still uses it as part of its parish hall.

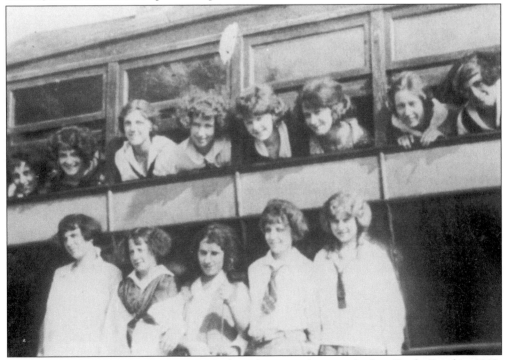

AN EARLY SCHOOL BUS, 1923. Buses such as this one, photographed on Banks Road in 1923, made the centralization of educational facilities possible. They led to the construction of the Samuel Staples Elementary School in 1930 and to the final closing of the town's outlying district schools. Why this photograph shows only female students remains a mystery.

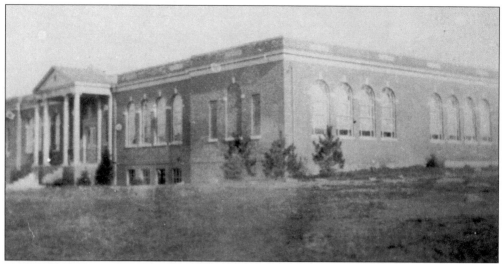

THE SAMUEL STAPLES ELEMENTARY SCHOOL, C. 1930. This photograph shows the Samuel Staples Elementary School just after it opened. At that time the whole school consisted of six classrooms arranged around a central auditorium. The auditorium served as a central meeting place for town meetings, as well as for a variety of other activities.

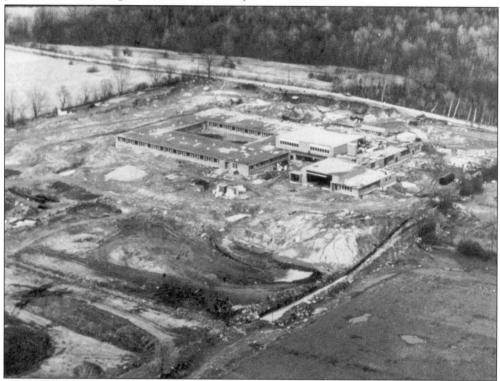

THE JOEL BARLOW HIGH SCHOOL, 1958. In the late 1950s, Redding was sending its students to Danbury High School for their secondary education and Easton students went to Bassick High School in Bridgeport. Crowding in those urban schools forced the towns to find an alternative for their youth's secondary education. The answer was Regional District No. 9, seen being built here on the old Burr farm in southern Redding.

86

Six

SPIRITUAL LIFE

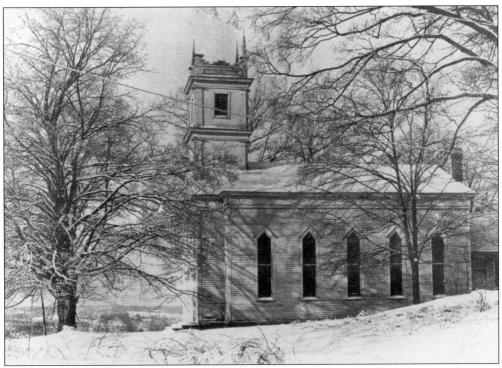

THE THIRD CONGREGATIONAL CHURCH BUILDING, C. 1930. The original Congregational church was built on Redding Green in 1732. In 1752, a second building was constructed on Great Pasture Road, just west of Route 107, the site that is shown here. In 1836, the second structure was replaced with the church that is pictured here. In 1921, with declining membership, the Congregationalists created a federated church with the Methodists and alternately used this building in the summer and the Methodist church on the Redding Green in the winter, since it had a better furnace.

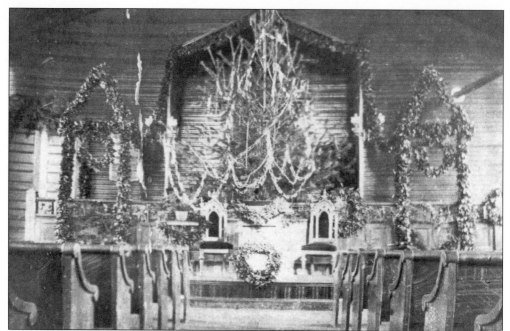

An Interior View of the Church, 1898. In 1893, the Congregational church building on Great Pasture Road underwent extensive remodeling. This interior view was taken just before Christmas, five years after that remodeling. This building burned on the afternoon of May 4, 1942, as the result of a cigarette that had been improperly disposed of. After the fire the congregation moved into the Methodist church on the green and used it year-round.

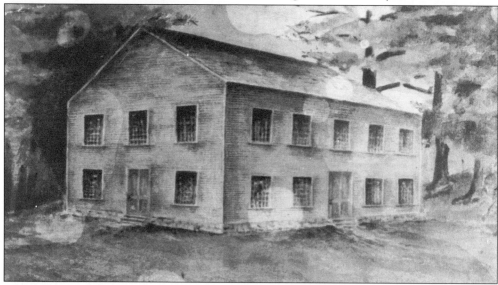

The Second Congregational Church Building, pre-1836. This sketch of the second Congregational church building was made by Alice Sanford from references to it in the parish minutes and other secondhand descriptions. The building has a typical 18th-century meetinghouse design, with the door in the long side of the building. However, the congregation never had the finances to add the typical bell tower and steeple. This sketch shows the way the building may have looked.

THE THIRD EPISCOPAL CHURCH BUILDING, C. 1887. The first Christ's Episcopal Church was built on the corner of Black Rock Turnpike and Cross Highway in 1733. It was replaced in 1750 and again in 1833, by the present building. On July 6, 1888, the building was reconsecrated, after being extensively enlarged and rebuilt. The telephone lines to the left of the building were strung in 1886; so, this photograph must date from sometime between 1886 and 1887.

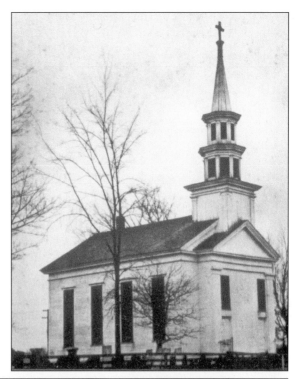

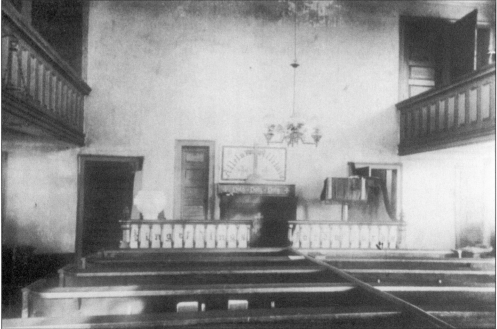

AN EARLY INTERIOR VIEW OF THE CHURCH, C. 1887. This is the only known photograph of the third church's interior before the rebuilding. At this point, the church still had its galleries and faced east, as was the tradition; when seated, the congregation faced Black Rock Turnpike. The long rectangular windows were changed in 1888, which is how this photograph and the previous one can be dated to the period before the rebuilding.

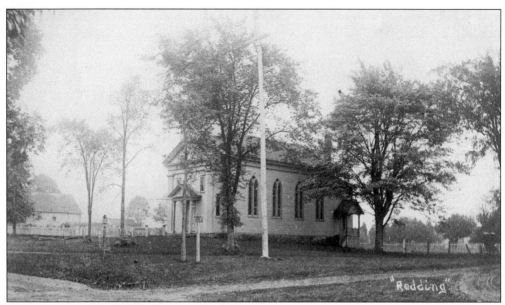

THE REBUILT THIRD EPISCOPAL CHURCH, C. 1907. This postcard view of the rebuilt church dates from 1907. The building was redone in a Neo-Gothic style, as is evident in the side windows, which are now in the form of a Gothic arch rather than a tall rectangle as before.

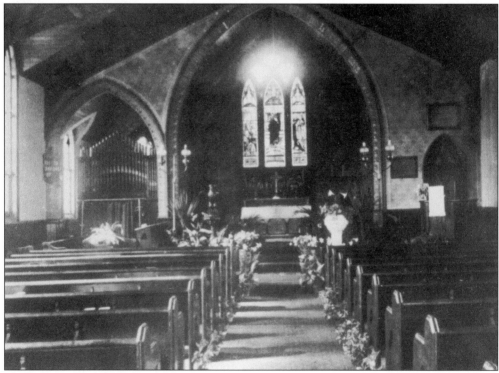

THE GOTHIC INTERIOR, C. 1900. The change to Gothic design is even more evident in this interior photograph. In fact, it is difficult to believe that this is the same church as the one shown on the previous page. The entire interior faces west (the congregation faces away from Black Rock Turnpike), and a great deal of stained glass has been added.

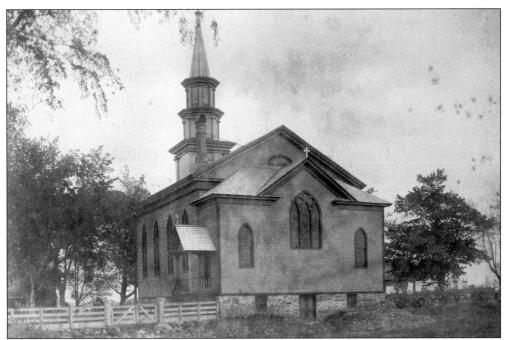

A Rear View of the Third Episcopal Church, c. 1900. Churches are rarely photographed from the rear. It is not clear what motivated the photographer from Bridgeport's Seeley & Warnock Studio to photograph this church that way; however, it is a valuable view because it shows the structure's 1888 addition and the large stained-glass window that was installed in the west wall. In 1964, the church was remodeled again and changed to a Neo-Colonial style.

The Cradle of Methodism, 1957. On December 28, 1789, when the circuit rider Jesse Lee first visited Redding, this house belonged to Aaron Sanford. Sanford converted to Methodism on that date and went on to become the first Methodist preacher in Connecticut, as well as the first male convert. Early Methodist services were held in this house until 1803, when the congregation rented the town house on the green for services.

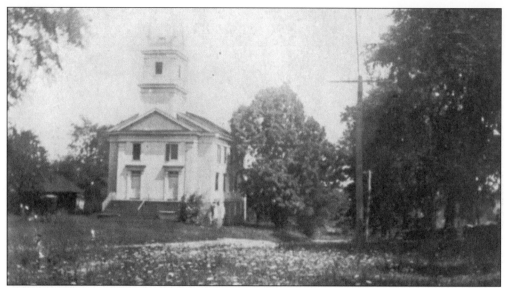

THE METHODIST CHURCH, C. 1910. The Methodists first built a temporary structure on this site in 1811. In 1837, they finally had Hiram Parmalee of Newtown construct this building, which still stands today. It was extensively rebuilt in 1868 and became part of the federated church with the Congregationalists in 1921. By 1958, its membership had dropped so low that the church was disbanded and the building became the Congregational church.

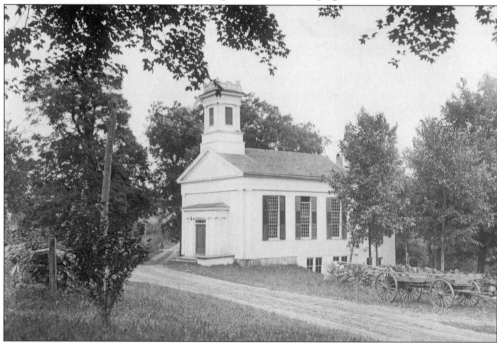

THE LONG RIDGE METHODIST CHURCH, C. 1920. Another Methodist church was established in West Redding, possibly as early as 1805. By 1820, the Methodists were able to construct their first building on Long Ridge Road, just north of the Redding boundary in Danbury. In 1842, they built this structure across the road from the original building. Although extensively renovated in 1946, this same building has served its congregation down to the present day.

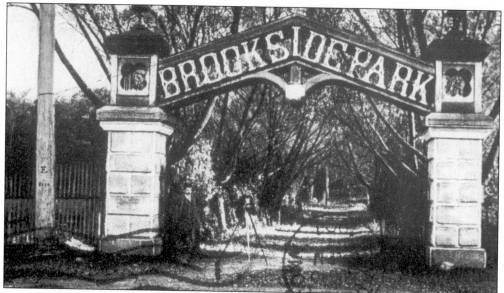

BROOKSIDE PARK, 1907. Throughout the 19th century, the Methodist church held revival or camp meetings to revive its membership's spiritual ardor. The first of these camp meetings in Connecticut was reputed to have been held in West Redding's Brookside Park *c.* 1810. Meetings continued to be held here yearly until 1860. In that year, because of difficulty in leasing the land, the meetings were moved to a grove in Milford.

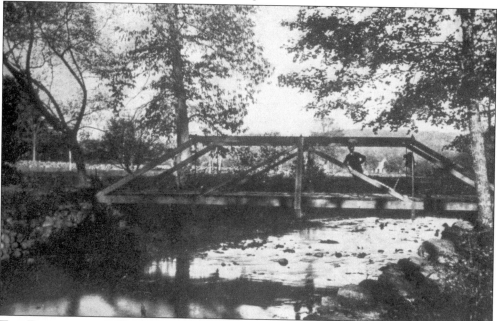

THE BRIDGE TO THE REVIVAL, C. 1905. Revival meetings were reinstituted at the park in 1878, but the Methodists still had to lease the land. In 1880, the Danbury and Norwalk Railroad purchased the park for use as part of its railroad excursions, which allowed families the opportunity to spend a day picnicking in the country. This image shows the bridge spanning the Saugatuck River, over which the Methodist faithful passed as they went to the heart of the revival area.

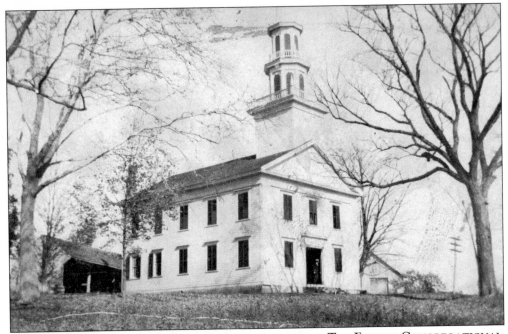

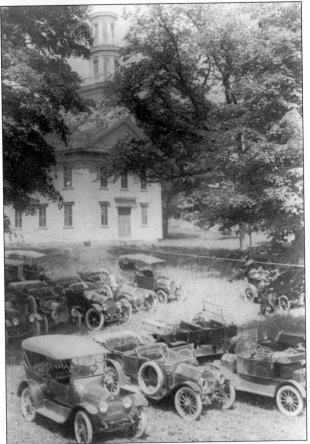

THE EASTON CONGREGATIONAL CHURCH, C. 1900. The first church on this site was built in 1763. The present church replaced it in 1836 and has remained virtually unchanged since then, which makes historical photographs of this church appear monotonous since they look the same regardless of when they were taken. Note the carriage sheds at the rear; these structures stood near every church in New England until the 1920s.

THE FRONT LAWN OF THE CHURCH, C. 1915. These automobiles scattered on the front lawn carried delegates from all over the state to attend the dedication of the new grange hall, which had been constructed on what is now the church parking lot. This photograph was taken from the upstairs window of the new grange hall.

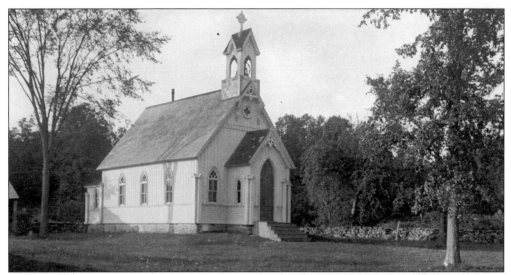

THE EPISCOPAL CHURCH OF EASTON, C. 1915. The small Episcopal congregation of Easton had been without a building since 1848 when they built this chapel in 1874. It was built in the new Carpenter Gothic style, achieved with the aid of the newly developed jigsaw, which enabled carpenters to emulate the stone tracery of Europe's great cathedrals. The building continued to be used as a chapel until 1950, when it was sold and turned into a private home.

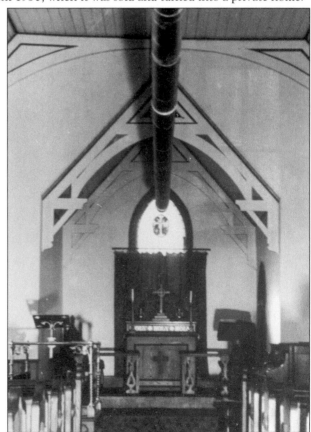

THE INTERIOR OF THE EPISCOPAL CHURCH, C. 1920. This photograph clearly shows that the Gothic style was carried into the interior. The decorative work in the upper corners near the ceiling was preserved when a second story was installed. Recently, Lisa Biageralli took the residence and restored it to near its 1870s appearance, finding the original windows and siding beneath the residential shingle siding in the process.

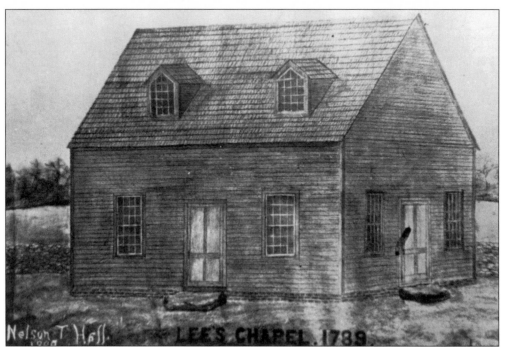

THE JESSE LEE CHAPEL, C. 1795. Jesse Lee made his first visit to this area seeking Methodist converts in 1789. On June 18 of that year, he arrived in Stratfield and preached a convincing sermon to Mrs. Wells and Mrs. Wheeler, both of whom converted and became the first Methodist congregation in New England. This sketch, by Nelson Hall, is of the first chapel in New England, built in 1795 and located on Park Avenue, just south of the Merritt Parkway.

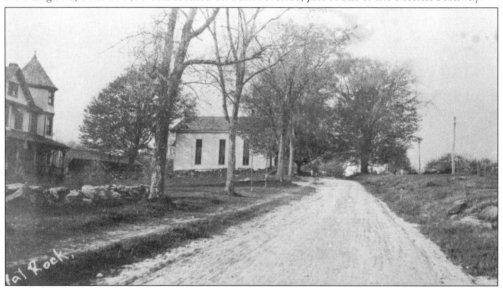

THE JESSE LEE METHODIST CHURCH, C. 1910. The chapel served until 1813. In that year, a new church was built on land donated by Daniel Sherwood in Easton. This photograph shows Flat Rock Road with the rebuilt 1813 church in the background. On the left is one of the typical vernacular Victorian houses that were built in rural towns such as Easton in the later years of the 19th century.

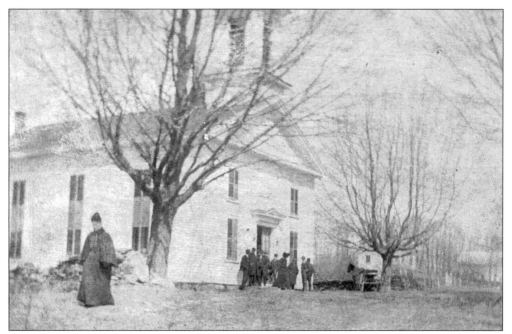

THE REBUILT CHURCH, C. 1900. This photograph shows the Jesse Lee Church at the end of the 19th century. In 1836, the earlier church building was stripped to the frame and rebuilt. The double entrance, one side for men and one side for women, was reduced to one entrance, and the overall appearance became similar to the churches that were built about the same time in Redding and Stepney.

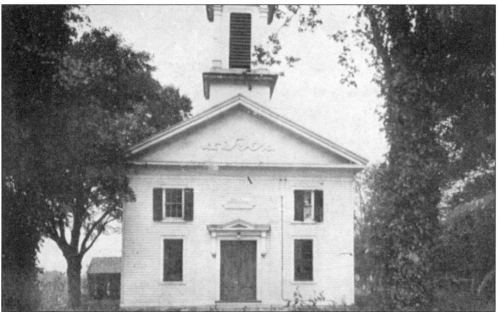

UNCHANGED FAÇADE, C. 1920. Except for the carriage sheds in the rear, the building in this 1920 view looks almost exactly as it does today. In fact, the only changes to the building in the 20th century were two additions: a classroom addition and a parish hall, both added to the rear. The façade has remained unchanged since 1836.

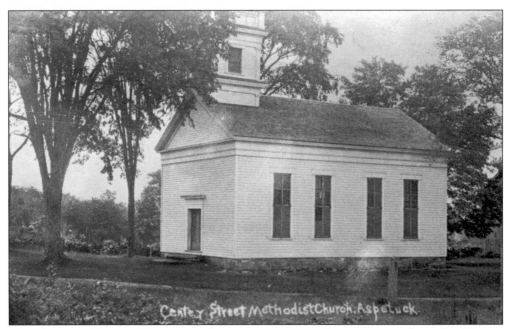

THE CENTER STREET METHODIST CHURCH, C. 1910. A scion group from the Weston Methodist Church in Lyons Plains built this church in 1844 on Redding Road, just north of the Fairfield border. (Redding Road was called Center Street because it was originally in the center of the town of Weston, of which Easton was part.) This Methodist church merged with the Jesse Lee Church in 1948, and the building was converted into a private dwelling.

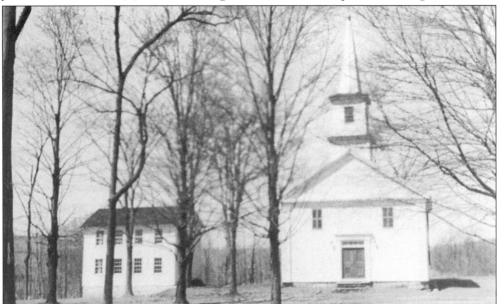

THE EASTON BAPTIST CHURCH, C. 1940. This building was constructed in 1829 at the corner of Church Road and Route 59, two years before the church was actually organized. The hope was that the fervor of the Baptist faith would soon fill the pews, which it did. The church was partially rebuilt in 1840, giving it the appearance shown here. The church was reorganized as the Faith Baptist Church in 1968.

Seven

REDDING AND EASTON AS A LITERARY AND SUMMER COLONY

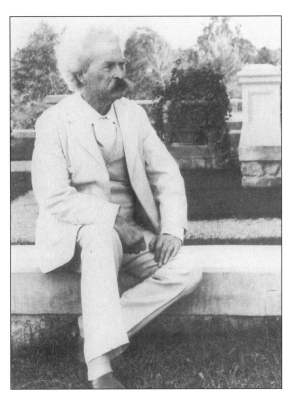

MARK TWAIN: THE SUMMER COLONY'S CENTER, 1909. In the last decades of the 19th century, with the failure of industry and agriculture, the populations of the towns of central Fairfield County declined dramatically. Redding and Easton were spared depopulation by the arrival of a substantial number of literary figures and artists. The most notable of these was author Mark Twain (Samuel Clemens), shown here at his Redding estate, Stormfield, in 1909.

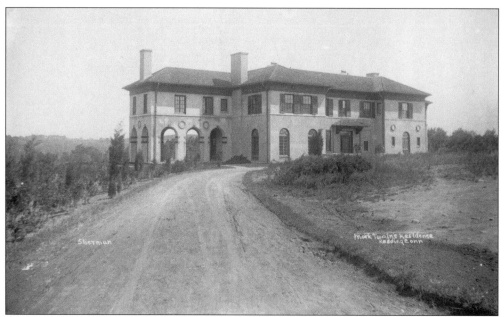

STORMFIELD, 1909. In 1906, Mark Twain purchased 200 acres of land, sight unseen, on a hilltop overlooking the Saugatuck Valley. He had architect John Howells design and build a replica Italian villa that was completed in 1908. In that year Twain came out to Redding to move into the house, which he was seeing for the first time. This house became his permanent residence until his death two years later.

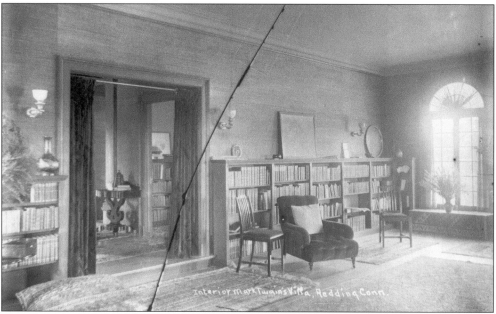

MARK TWAIN'S SUMMER ESTATE, 1909. Besides the room containing his beloved billiard table, the library (shown here in this cracked glass plate negative) was Mark Twain's favorite room. The last formal portraits of Twain were taken in the easy chair shown here. Twain's estate took its name from the main character in *Extracts from Captain Stormfield's Visit to Heaven*, one of his last books.

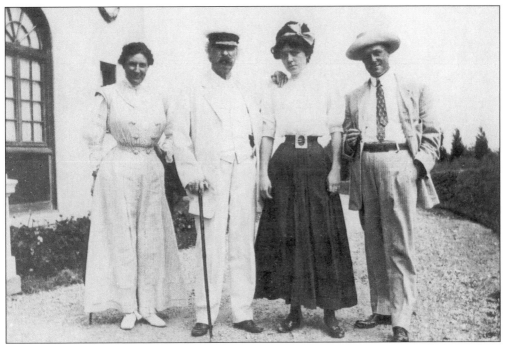

THE STAFF AT STORMFIELD, 1909. Mark Twain, second from left, appears on the Stormfield terrace with members of his staff, from left to right, housekeeper Isabel S. Wayland, private secretary Miss Lyons, and grounds keeper John Elton Wayland. Not pictured is Albert Bigelow Paine, Twain's biographer and constant companion during the author's last years.

THE WEDDING OF MARK TWAIN'S DAUGHTER, OCTOBER 6, 1909. Besides his own death, two pivotal events in Mark Twain's life occurred in Redding: the tragic death of his daughter Jean and the wedding of his other daughter, Clara. Shown here at Stormfield are, from left to right, Twain in his Oxford gown, nephew Jervis Langdon, daughter Jean, groom Ossip Gabrilowitsch, daughter Clara, and the Reverend Joseph Twitchell—the longtime friend of Twain who performed the wedding ceremony.

THE MARK TWAIN LIBRARY, C. 1915. His love of books and the lack of a local library led Mark Twain to spearhead an effort to build a library for the town. Every visitor to Twain's house was asked to contribute to the project, and the sale of daughter Jean's little farm after her death added substantially to the building fund. This building is known formally as the Jean Clemens Memorial.

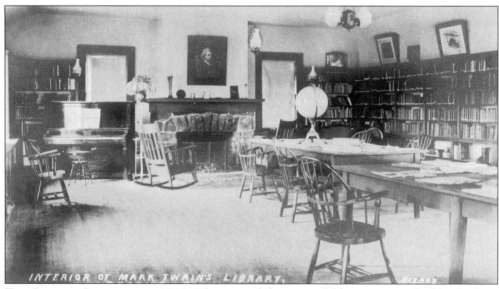

THE LIBRARY INTERIOR, C. 1910. The core of the original library consisted of books from Mark Twain's own library. Twain was the first president of the library association, and W.E. Grummon, the author of *The Revolutionary Soldiers of Redding*, was its first librarian. The interior scene shown here remained almost unchanged until the massive round addition of 1970.

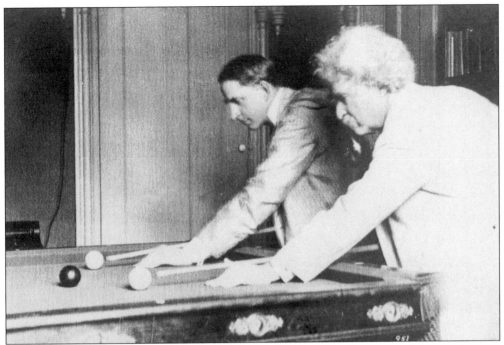

MARK TWAIN AND ALBERT BIGELOW PAINE, 1905. Albert Bigelow Paine, left, was the man who introduced Mark Twain to Redding. The two are shown playing their favorite game. Paine had a house on what is now Mark Twain Lane and was a constant visitor to Stormfield. In addition to being a constant companion, Paine was gathering material for his massive three-volume biography of Twain, which appeared in 1912, two years after Twain's death.

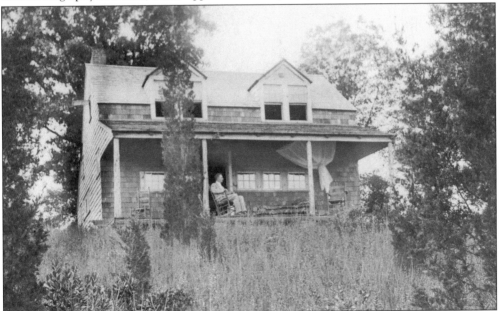

RELAXING AT MARKLAND, 1909. With Mark Twain's encouragement, Albert Paine built a literary retreat and office on the hill above his house. He called the retreat Markland, which greatly flattered its namesake. Paine is shown here relaxing on the front porch.

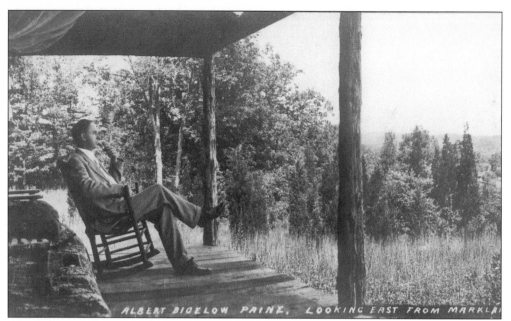

ALBERT BIGELOW PAINE. LOOKING EAST FROM MARKLA

THE PORCH AT MARKLAND, 1909. A closer view shows Albert Paine on his porch, with the Saugatuck Valley extending off to the right. It was here that Paine often entertained Daniel Carter Beard, a friend of Mark Twain's and the illustrator of Twain's *The Connecticut Yankee at King Arthur's Court*. Beard lived on Great Pasture Road, in the second house in from Route 53.

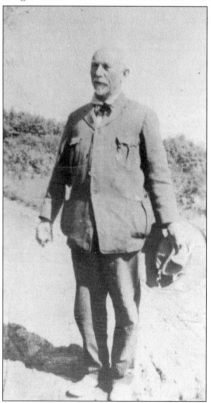

DANIEL CARTER BEARD, C. 1915. Daniel Carter Beard was an illustrator by profession but while he lived in Redding, he founded the Boy Pioneers. The Boy Pioneers merged with the Boy Scouts of America upon incorporation in 1910. Beard is considered to be one of the principal founders of the Boy Scouts, and he later earned the organization's highest honor, the Golden Beaver, for his lifetime of work in scouting.

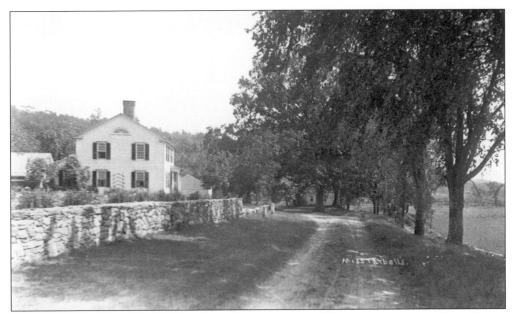

THE IDA TARBELL HOUSE, C. 1915. Located on Valley Road, just below its junction with Rock House Road, is this small three-bay house built c. 1815 by Eliphlet Bradley. In 1905, the house was bought by well-known author Ida Tarbell, who lived and wrote here for the next 40 years. The author's sister Sarah settled just to the east on Rock House Road.

THE AUTHOR'S HOUSE, C. 1915. Ida Tarbell was best known for her muckraking two-volume history of the Standard Oil Company, which was published in 1904. She also wrote two biographical works on Abraham Lincoln. She was first attracted to this area by the Hoggesons of Poverty Hollow, and through their mutual friendship with Henry Rogers of Standard Oil, she became friends with her Redding neighbor Mark Twain.

A TARBELL WEDDING, 1914. On June 24, 1914, the Tarbell homestead was the site of a moderately lavish outdoor wedding. Ida Tarbell's niece Esther Ida Tarbell married J.M. Aldrich under the property's stately oaks. Both Esther and niece Clara frequently stayed in the little guest house located just to the south of the main house, which was once a workshop for the local poorhouse.

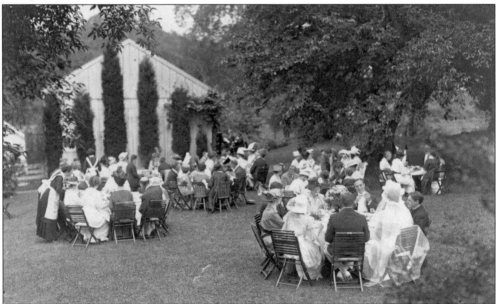

THE WEDDING RECEPTION, 1914. The reception for Esther Tarbell's wedding was also held in the well-manicured side yard. The Tarbell residence was a hostel for many notable personalities of the time, among whom was communist sympathizer Jack Reed, who frequently walked overland from the West Redding Station to join the Tarbells for several days at a time. In her autobiography Ida Tarbell laments Reed's death and burial in Lenin's Moscow.

THE BELLAMY PARTRIDGE HOUSE, c. 1920. Among the later generation of literary figures who came to the area was novelist Bellamy Partridge. In the late 1930s, Partridge and his wife moved into and extensively remodeled this house on Silver Hill Road (formerly known as Lazy Road). The house, a fine example of the center-chimney Colonial style, was reputedly built *c.* 1760.

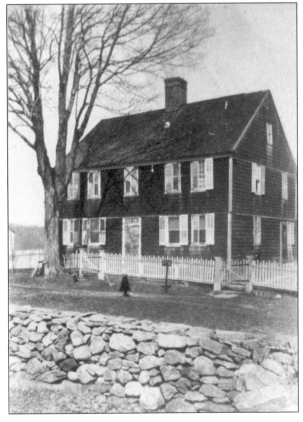

THE SETTING FOR A PARTRIDGE NOVEL, c. 1910. The later literary generation included Edna Ferber and Betty Speare. Edna Ferber wrote *Giant* while living in her home off of Maple Road. Betty Speare lived on the west end of Adams Road and won the Newberry Award for her juvenile masterpiece *The Witch of Blackberry Pond*. Bellamy Partridge wrote many comedic novels, several of which were set in Easton. One of them, *January Thaw*, was actually set in this house.

THE MAN OF JANUARY THAW, 1906. When Bellamy Partridge bought his house from the Bridgeport Hydraulic Company, he did it with the understanding that the former owner, James Taylor, had life use of the house if he ever came back. The plot of *January Thaw* revolves around what would have happened had the old Yankee returned. This photograph shows Taylor and his wife Sarah in 1906, long before the Partridge purchase.

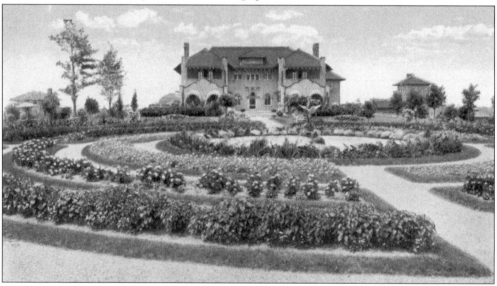

THE LUTTGEN RESIDENCE, C. 1912. Between 1909 and 1914, summer resident Commo. Walter Luttgen put together an 880-acre estate on Sunset Hill Road, complete with this beautiful house, a formal garden, and large lakes that accommodated his steam launch. Archer Huntington acquired the property in 1939 and being dreadfully afraid of fires, he tore down this house and replaced it with a fireproof one. This estate is now the Huntington State Park.

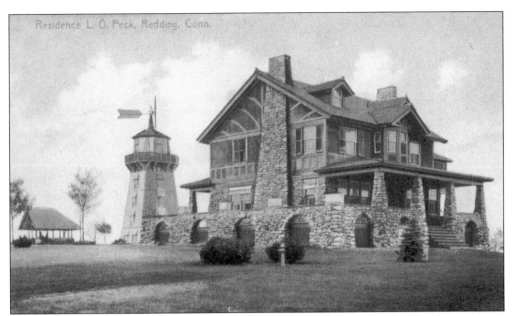

Residence L. O. Peck, Redding. Conn.

THE WIANTENUCK FARM, C. 1910. After the beginning of the 20th century, many affluent men, such as Commo. Walter Luttgen, built residences in Redding and Easton to serve as weekend and summer retreats. Six years before Luttgen settled on Sunset Hill, Sen. Lester O. Peck built this modest cottage, which dominated the southern crest of the same hill.

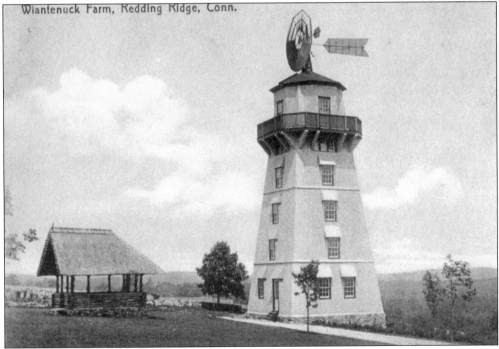

Wiantenuck Farm, Redding Ridge, Conn.

A LOCAL LANDMARK, C. 1910. This windmill, which rapidly became a local landmark, was used not only to raise water for the cistern at Wiantenuck Farm but also as a pleasant lookout over the surrounding countryside. Before the slopes became reforested, Sen. Lester Peck could see all the way to Long Island Sound from here.

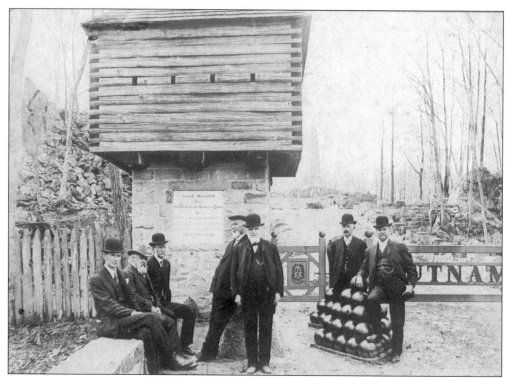

PUTNAM MEMORIAL PARK, 1902. Putnam Memorial Park, the site of an encampment of Revolutionary War soldiers in the winter of 1778 to 1779, became one of Connecticut's first state parks in 1887. It has since become one of the area's most popular summer attractions. Shown here are some of the park's founders, from left to right, Thomas A. Evans, George G. Parker, William H. Hill, chairman John H. Jennings, William Ward, Clarence Hickock, and Charles H. Peck.

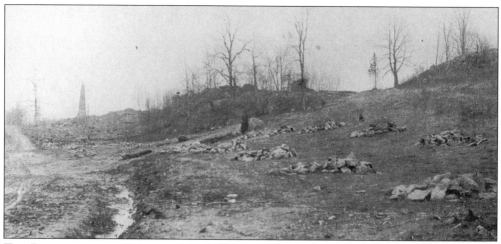

THE REMAINS OF THE ENLISTED MEN'S HUTS, C. 1893. Putnam Memorial Park was heavily landscaped and nearly 2 miles of roads were built to give access to the park's various Revolutionary War features. This view shows the company street during the early phases of landscaping. The piles of rock on the right are the collapsed chimney remains of the enlisted men's huts, each of which measured 16 feet by 12 feet and housed 12 men.

THE COMPLETED COMPANY ROAD, 1902. This view of Putnam Memorial Park shows the same area ten years later, with a completed road and a lawn around the chimney remains. The enlisted men's huts were arranged in two rows, extending about a quarter of a mile along this street. Recent archaeology has discovered that the huts extended to the east of each chimney ruin (toward the road) with a very narrow alley of only 8 feet between the rows.

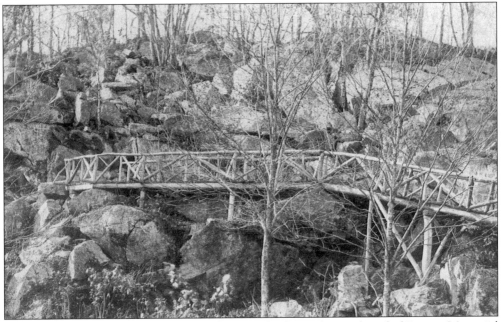

THE BRIDGE TO PHILIPS CAVE, 1902. This rustic bridge in the north end of Putnam Memorial Park led visitors to Philips Cave. According to legend, after the American Revolution, a destitute ex-soldier (some say a local Native American) took up residence in one of the natural rockfall caves from which he ventured forth to steal chickens from the surrounding farms. The local farmers, growing tired of their losses, ambushed him one afternoon and shot him dead.

THE BURYING GROUND MARKER, 1902. Erected in Putnam Memorial Park shortly before 1902, this marker indicates that according to oral tradition, this area is the burying ground of 25 soldiers who died during the winter of 1778 to 1779. Recent archaeology conducted by the author and his Redding assistant, Kathleen von Jena, discovered that to the contrary, this is the site of a field officer's quarters. The marker remains as a memorial to the casualties who were from New Hampshire and Canada.

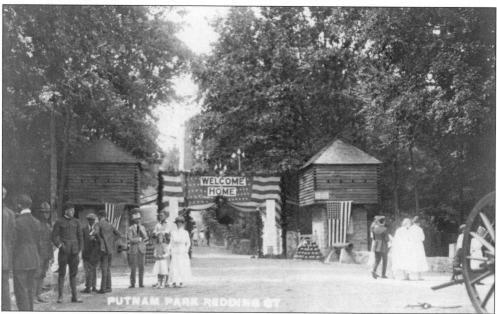

WELCOMING THE SOLDIERS HOME, 1919. Putnam Memorial Park has been the focus of many activities for the surrounding towns, as well as Redding. Numerous Sunday school outings, public school picnics and field days, and commemorative events have been held in the park. This view shows a reception welcoming home the soldiers of World War I. It was attended by the lieutenant governor and most of the town's officials.

Eight
SPECIAL EVENTS AND NOTABLE PEOPLE

A CHURCH PAGEANT, C. 1920. Any town or community earns its identity from the notable people who live in it and the special events that occur there. This chapter contains a selection of those people and events that have given Redding and Easton their unique character. Pictured above are the players of a pageant put on by Redding's Christ Church *c*. 1920. The subject of the pageant was Queen Esther, and the players were church members and selected residents of the community.

BILL RYDER AT THE WHEEL, C. 1920. Farmers were the backbone of the community from the time of first settlement until the mid-19th century. They gave this area its rural character and were, therefore, of significance. They included some of the region's last farmers, such as Bill Ryder, shown here at the wheel of his new Ford. Ryder's farm supplied several of the photographs of typical farm life that appear in the first chapter.

DIDO THE ENGINEER, C. 1920. Among the extraordinary people who made the community distinct was John Nickerson Jr. Nickerson, left, is reputed to have been one of the greatest engineers on the New Haven Railroad. He was known as Dido, although the reason for that name is not known. He ran the *Yankee Clipper*, the pride of the New Haven Railroad's trains. He lived on Hill Road during his working life and retired to Roxbury.

114

HANNAH SANFORD AND HER TRICYCLE, C. 1890. Hannah Sherwood Sanford was the wife of Charles Sanford, one of the sons of Squire James Sanford, who was the industrial pioneer of the Foundry District. Born in 1852, she was the owner of a very special and unusual means of conveyance: a tricycle. One can only guess at how easily she was able to negotiate the hilly dirt roads of Redding.

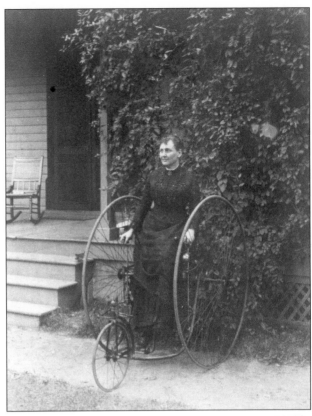

THE WARNER LIVERY, C. 1910. This unusual tintype shows Llewellyn "Lew" Warner (the father of Barbara Obeda) at the wheel of Redding's first livery. Just behind Warner is his wife, Minnie, and behind her is his sister Pearl Goodsell. This photograph is more unusual than most because the car and its passengers are posing in a studio. Note the flag draped near the rear wheel.

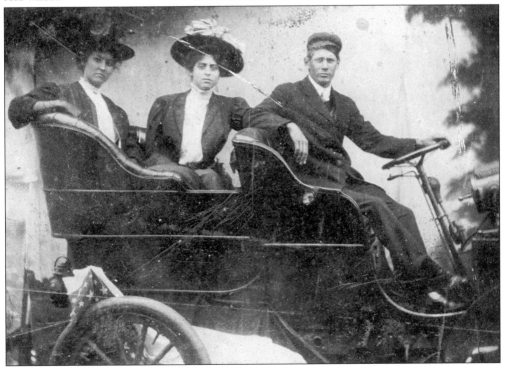

MAY DAY, C. 1930. A very special event was this May Day ceremony, performed at the Hill Academy after it had become a town school. Leaning against the school building are students and parents who have come to watch the schoolchildren perform a typical dance around the Maypole.

THE ARCH OF SPRING, C. 1930. At another point in the May Day ceremony, the angels who are heralding the arrival of spring form an arch with their trumpets, under which the Maypole dancers pass. The day was truly special because it served to get the participants out of class.

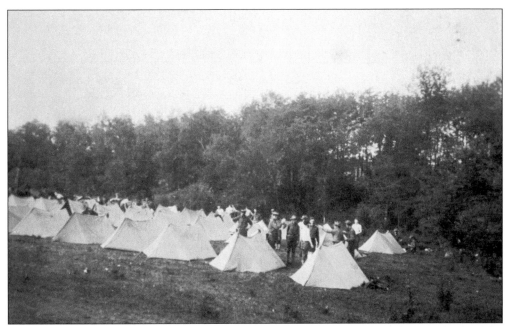

ARMY MANEUVERS, 1912. This camp for the Blue Army was located on the west bank of the Aspetuck River, just north of Church Hill Road (where Great Meadow Road is today). The maneuvers were part of a gigantic war game, the object of which was to capture New York City. This part of the Blue Army was preparing to stop the advance of the Red Army, which was invading from New Haven.

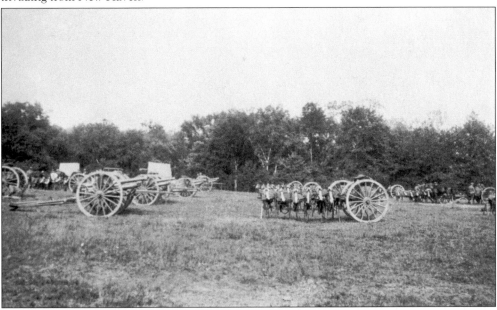

THE ARTILLERY COMPANY'S EQUIPMENT, 1912. This portion of the Blue Army included an infantry and an artillery company. This view shows the artillery company's equipment during maneuvers. The encampment was on August 14, 1912, just three days before the final battle in Newtown. Overall, the entire regular U.S. Army for the East Coast and several militia companies from the surrounding states were involved, including a total of about 10,000 troops.

117

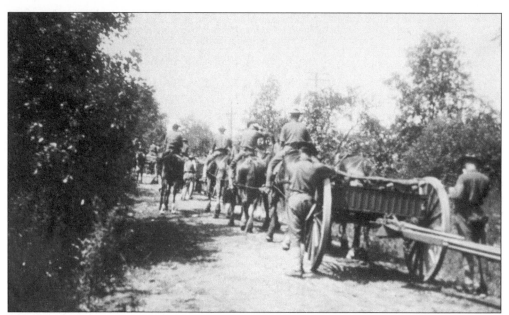

THE ARTILLERY MOVES ON, 1912. During maneuvers the artillery company pulls out of camp and heads up Church Hill Road on the morning of August 15, 1912. The men proceeded to southern Newtown and eventually set up on the south slope of Castle Hill, located immediately to the west of Newtown Village. There, they tried to stop a Red Army assault on Saturday, August 17, 1912; they failed.

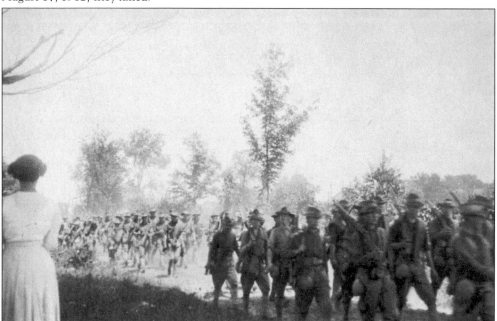

THE INFANTRY MARCHES NORTH, 1912. The infantry company also pulls out and marches north along Poverty Hollow Road, which is lined with curious Redding residents. On August 17, 1912, north of Newtown Village, the men managed to push the Red Army back. This action made the maneuvers a draw. The movement of the troops through all of the towns of central Fairfield County was a topic of excited conversation for several generations.

EBENEZER GILBERT, C. 1895.
In 1861, Ebenezer Gilbert
inherited the Eli Adams tavern
from his father-in-law. The
tavern was located on the
southwest corner of Adams
and Sport Hill Roads, and it
was a gathering place for war
veterans. Although the last
Revolutionary War veteran,
Nehemiah Webb Lyon, had
died the year before, veterans
of the War of 1812 and the
Civil War took his place to tell
stories of their own wartime
adventures. (See page 35.)

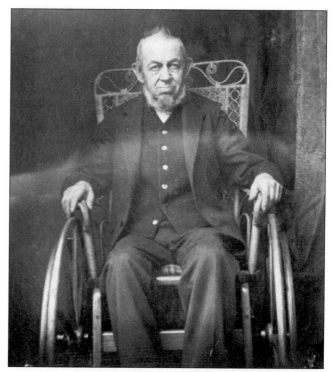

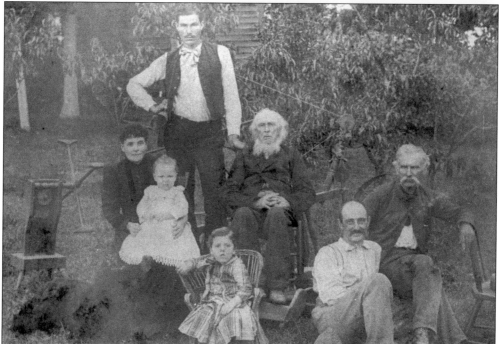

JOHN FREEZE, THE FIRST CATHOLIC, C. 1910. John Freeze, in the center wearing a beard, was
reputed to be the first foreigner to move to Easton. He came from Ireland before the Civil War
and thus became the first Catholic in Easton. After St. Patrick's Church was built on Redding
Ridge in 1880, Freeze walked to it every Sunday from his Adams Road home.

MICHAEL SVIHRA AND THE CZECHOSLOVAKIAN MIGRATION, C. 1920. By 1900, Easton's population had dropped to 960 because of failed industry and unprofitable farming. Shortly after the start of the 20th century, Paul Svihra saw several of the abandoned farms here and wrote to his former neighbors in Dovalova, Czechoslovakia, who quickly arrived and increased Easton's population. Shown here is Svihra's son Michael Svihra, whose son Oscar Svihra became one of Easton's first police chiefs.

BILL GREGORY, 1895. Bill Gregory, who was also known locally as Bill Indian, was one of the last of the Native American descendants in this area. He lived in a small dwelling at the intersection of Sport Hill and Rock House Roads and did chores and day work for the surrounding farmers. It is not known what happened to him after he left Easton in the early years of the 20th century.

FIRST RURAL FREE DELIVERYMAN, C. 1920. Rural free delivery was first introduced to the area in the 1890s. Shortly afterward, several citizens of Easton petitioned the post office to start the service here. Charlie Wixson was the first to deliver the rural mail. He is shown next to the automobile that replaced the horse and wagon that he used when first delivering the mail.

DELIVERY BY SLEIGH, C. 1925. In order to get rural free delivery service, the petitioners had to put together a 25-mile route and get at least 100 people to agree to have their mail delivered to a box in front of their house. Early mail carrier Charlie Wixson is pictured delivering mail by sleigh. Rain, sleet, and snow may have stopped Wixson's car, but it did not stop the mail delivery.

SAMUEL P. SENIOR, C. 1950. Samuel Senior served as the president of the Bridgeport Hydraulic Company from 1920 to 1955. He guided the company's acquisition of property in both Redding and Easton until the company controlled more than 40 percent of Easton's land surface. He lived on the crest of the hill on the southern end of Sport Hill Road. Today, he is commemorated by a small public park across from the town hall.

THE FOREST RANGERS, 1933. The Easton Forest Rangers are reputed to have been the first forest fire rangers in the state. Posing at the University of Connecticut in July 1933, the rangers are about to start on a training trip to Rutland, Vermont—a trip that resulted in 21 flat tires. They are, from left to right, Jay Sherwood Edwards, John King, Sterling Gillette, Edward Johnson, Albert Wilkes, and Fred O'Hara.

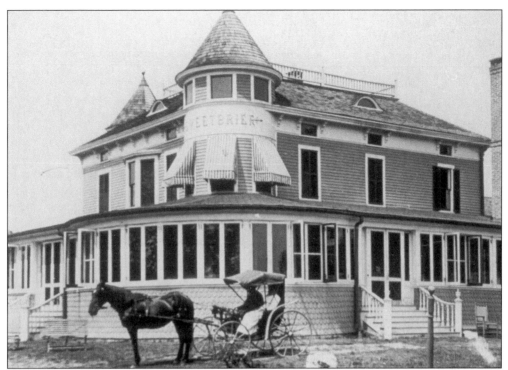

SYLVANUS MALLET AND SWEETBRIAR, C. 1910. Sylvanus Mallet pushed the old Mallett homestead back on its lot and built Sweetbriar *c.* 1893. Sweetbriar, a stately example of a late-Victorian, Queen Ann-style house, is probably the best example of Victorian architecture in Easton. Pictured are Mallet and his wife, Mary Marsh, about to embark on a short journey in a typical conveyance of the time. (See page 22.)

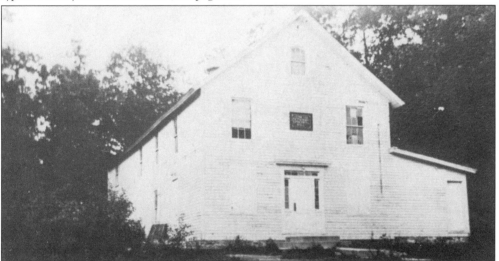

THE TEMPERANCE HALL, C. 1920. Friendship Hall lies on the north side of Flat Rock Road, just beyond Jesse Lee Drive. The Sincerity Lodge 174 of the Independent Order of Good Templars, Easton's temperance society, built the hall in 1875. In 1878, the noted teetotaler and showman P.T. Barnum spoke here. The building was sold to the Methodists as a parish hall in 1893; in 1953, it became a residence.

THE SPORT HILL RACES, 1908. Sport Hill Road got its name from the hill climb races that were held on the southern end of that road between 1906 and 1911. The starting line was at the bridge that crossed the Mill River, shown here in 1908, as Ed Coffey begins the climb in his Colombia car. The finish line was at Flat Rock Road.

THE WINNING CAR, 1908. The winner of the 1908 Sport Hill race was Al Poole in his Isotta car, with a winning time of one minute and 17 seconds. A telephone line was strung along the race route,q with ten listening stations spaced at nearly equal intervals. Thus, spectators could follow the action at each station even though the racing cars were out of sight.

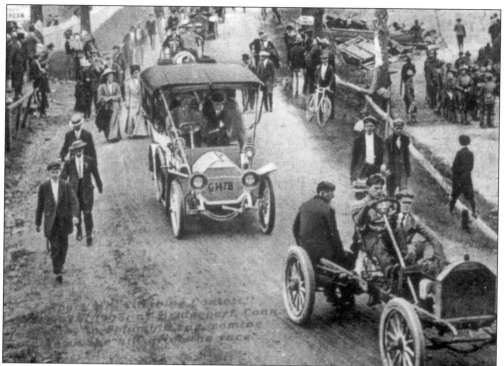

END OF A BIG EVENT, 1908. The race has ended, and the contestants are returning to the starting line. The races were sponsored by the Bridgeport Automobile Club and were always held on the last weekend in May. In 1908, some 10,000 spectators lined the route, making the Sport Hill race one of the largest motor sport events of the year.

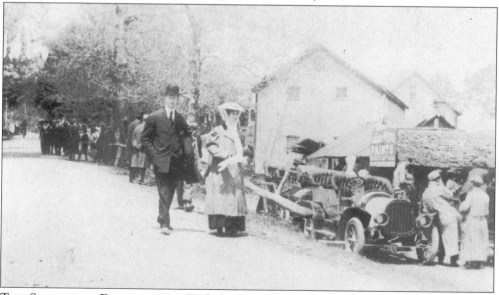

TWO SPECTATORS DEPART, 1908. With the Sport Hill race over, two spectators return to their own auto to leave. This photograph, beside capturing the atmosphere of the time, shows the Lacy and Platt mills, from which Plattsville got its name. The photograph, looking north toward Easton, was taken from the bridge that crosses the Mill River.

THE DEDICATION OF THE NEW GRANGE, 1915. On June 2, 1915, the Easton Grange dedicated its new building, constructed on what is now the Congregational church parking lot. Grange officers from all over the state line up to march from the grange's old meeting room, located over Osborne's (now Grieser's) store, to the new hall across the street. (See page 40.)

THE FIRST OF MANY FUNCTIONS, 1915. Residents attend the dedication of the new grange in 1915. In this building the meeting room and stage were on the second floor and the first floor contained a kitchen and dining room, which served to refresh the Easton residents who attended the many functions that were held here. The building was destroyed by fire on December 6, 1931. Two years later a new hall was dedicated across from the town hall. That structure is now the Masonic Lodge building. (See page 40.)

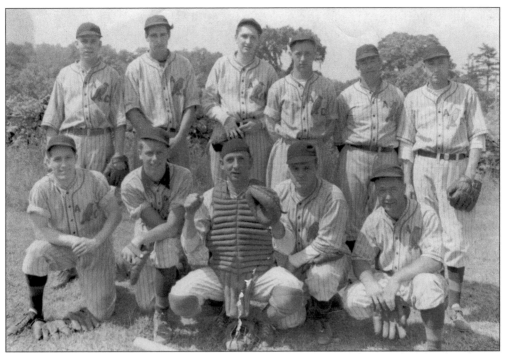

THE BLUEBIRD ATHLETIC CLUB, 1937. Sponsored by the Bluebird Inn, this athletic club and baseball team was active in the years before the World War II. Little is known of the team's activities or longevity. Seen here, from left to right, are the following: (front row) Bill James, Frank Marlin, Kenny Benedict, Wes Norton, and Bill Lee; (back row) Dickie Kearns, Jess Sherwood, Jack Lindsay, Franklin Lobdell, Harold Jennings, and Brad Driesen.

HISTORIAN FRANCIS MELLEN (1908–1981), C. 1970. Although out of place in this collection of pre-World War II images, this photograph of Easton's first historian is included here with good reason. Francis Mellen collected the history of Easton all during his life, and his collections made possible the publication of the first history of Easton in 1972. Mellen continued the legacy of his father, John Zebina Mellen, whose passion for local history was equal to his son's.

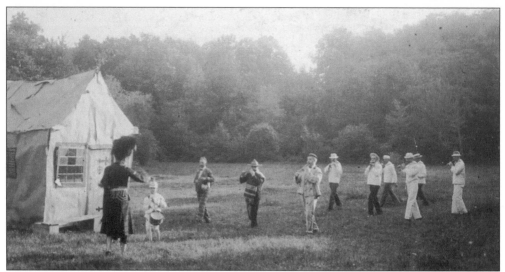

PIPING IN THE FOURTH OF JULY, C. 1910. In Poverty Hollow, Noble Hoggeston and his impromptu band pipe in the Fourth of July c. 1910. Hoggeston refurbished an old colonial house, to which he retreated from New York on weekends and during the summer. He and his weekend neighbors formed a fun-loving group called the Valley Crowd. Hoggeston's house still stands at the northeast corner of the intersection of Church Hill and Poverty Hollow Roads.

THE PAPER HOUSE IN POVERTY HOLLOW, C. 1910. This paper playhouse, which also appears in the previous photograph, typifies the informal stunts, pageants, and high jinks that the Valley Crowd delighted in during the first quarter of the 20th century. Constructed specifically for the Fourth of July celebration, the house was later burned down for the benefit of the local volunteer fire company.